ANTHONY GREEN

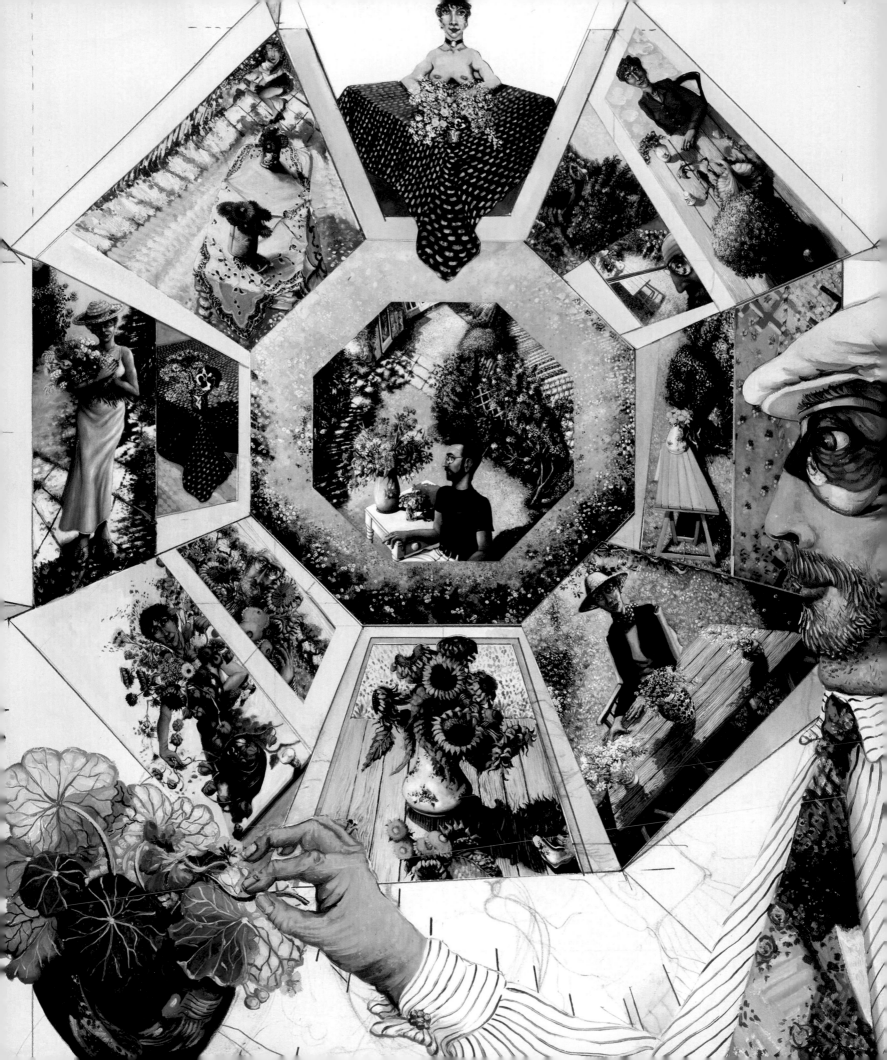

ANTHONY GREEN

Printed Pictures

Paul E H Davis

A catalogue of prints by Anthony Green held in
the University of Buckingham Collection

A catalogue record of this book is available from the British Library

ISBN 978-1-912500-04-8

Every effort has been made to identify all those who are responsible for the works and images reproduced in this book. If they have not been acknowledged and can be identified following publication, the publishers will happily acknowledge them in any future reprint.

NOTE TO THE READER:
Throughout the book, the letters and numbers following the titles of the pictures refer either to original paintings and correspond to the catalogue raisonné (AG) or to the catalogue of prints (PG).

Previous page: *The Flower Painter*, 2006. PG31. *The Flower Painter* was made in 2006 and published in an edition of 70 – 'my flowers hang in lots of homes'.

Artist's Acknowledgements

My special thanks to Paul Davis who with his essay has sensitively revealed an ordinary man behind the public artist. Christopher Woodhead and Tom Chalmers, at the University of Buckingham Press, happily tolerated our literary and artistic indulgences. Week by week, Shelagh Bidwell, my 'printed picture' co-ordinator, ensured that paintings, reproductions and photographs became digital and usable. In the 1980s, John Hutchings, at The Curwen Press, commissioned my first lithographs; his Master Printer, Stanley Jones, proofed and printed them. Later, John Hutchings exhibited my works at The Curwen Gallery. Professor Norman Ackroyd RA, in 1995, introduced me to soft ground etching. Kip Gresham printed my first *Resurrection* screen prints and included *Bob Going to Heaven Quickly* in the King's College Cambridge portfolio (1999). He continues to print and etch beautifully for me. Over the years, Alex Harrington and Darren Meaker of Skyblue Digital, Dick Gilliver of Rich Tapestry and Nigel Bush and Simon Hawkins, at Reeve Photography, photographed and oversaw my inkjet print projects. From 1988, Faith Hallett and Susan Ladenburg of Whitcombe Associates have, in addition to being my agents, managed and co-ordinated my photographic archive – expanding my growing list of print collectors. Since 2015, Chris Beetles Gallery, in St James's, has exclusively represented me.

Anthony Green RA

Contents

Anthony Green has done something remarkable. In the teeth of the prevailing consensus, and with magnificent and characteristic independence, he has succeeded in achieving one of the first tests of significance for any painter: namely to create a consistent style and vision that we instantly recognise. The world he presents to us is essentially humane. Deeply aware of art's history and aesthetics but never pushed off course by them, he has made the events and surroundings of his life his subject. This is a world where family, home, memory and indeed love itself are resplendently at the centre. For all this and for his honesty, loyalty – and occasional sheer bloody-mindedness – I salute him.

Christopher Le Brun, President of the Royal Academy

Anthony Green is very much a Buckingham person, a long serving and enthusiastic member of our Council, notable for his courtesy, his perception, and quiet work behind the scenes that has been crucial to the establishment and success of our degree programmes in Art History.

Prof John Clarke, University of Buckingham, on Anthony Green RA being awarded an Honorary Doctorate in 2011

My whole involvement with Buckingham has been one of pure pleasure. I was so proud to have been asked to be on the University Council, which I was for 10 years, and I enjoyed every moment of it, and it really is a great pleasure to give the university the prints. It's a joy to see that art has now become central to Buckingham's image, and I am so pleased that, during my time there, it all came about, and Art History is now going strong.

Anthony Green RA, 2018

A Chronicler of Life
Paul E H Davis

I passionately believe in figurative art and totally reject suggestions that
it has lost its relevance. Since man first scratched magic images on cave
walls thirty-five thousand years ago, he has looked at himself in his
mirror: gazing upon his fears, aspirations and possessions. Too often
the contemporary artist uses a clouded mirror.[1]

Anthony Green RA, 1984

As a schoolboy visiting The Louvre, I discovered a treasure trove of
magnificent French paintings. At school, my art master, Kyffin Williams,
introduced me to oil paints, turpentine, linseed oil and a large palette.
The Slade taught me to draw and by 1960 presented me with its
diploma – by which time I had danced with and kissed the most
beautiful girl there. As a very young artist this was the crucial
breakthrough – I would chronicle my love for Mary and our continuing
story. I love Mary Green a lot. That's why I paint.[2]

Anthony Green RA, 2006

A Love Story

Anthony Green is a truly original artist and has been variously described as one of
our most distinguished living artists, one of our most eminent figurative painters
and one of our best narrative painters – but others consider him to be suffering from
arrested adolescence. The fact is that, above all else, he is a chronicler. He is
certainly a force of nature, a bon vivant with a larger than life presence and a quick,
self-deprecating wit, who paints bright, humorous and accessible pictures. The key
fact is, however, that without Mary Cozens-Walker there would simply never have
been Anthony Green the painter.

Anthony and Mary are inseparable both in life and work. Anyone who has had
the privilege of spending time with them quickly realises that theirs is a symbiotic
relationship: it is deep and real and not superficial or syrupy. They met at the Slade
in 1957, were engaged for four years and married in 1961. When Anthony asked
Bob Cozens-Walker for permission to marry his daughter, quick as flash came the
question: 'Have you seen her mother?' Fortunately, Anthony, being equally quick,
replied: 'Yes, and I think she's terrific!' Once married, they moved into 17 Lissenden
Mansions, London, Anthony's childhood home, which had recently become vacant
on the death of his father. In order to support them and in turn their growing family,
Anthony taught art part time at his old school in Highgate and then at the Slade.
He was soon able, by about 1969, to support his family almost exclusively through
the sale of his work. He comes from a generation when being a professional artist
in England was considered vulgar. It was amateurism that was praised; being half-
French, however, Anthony had no time for such misplaced snobbery.

Anthony and Mary, 1957

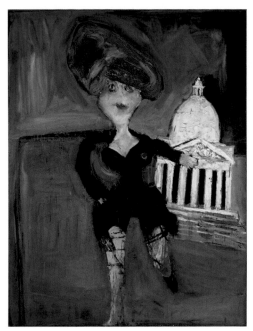

Mother-in-Law I,
1961-62. AG14

After being elected an Associate Royal Academician in 1971 – becoming a full RA in 1977 – he served on numerous Academy committees. He takes his position seriously and is realistic about his fellow Academicians and the challenge they all face: 'Most of the artists who join do so because they have done something remarkable in art and, with a bit of luck, they're going to keep the flag of civilization flying, not in a nasty academic way but in a generous way. To be an artist over a period of 50 years, you can't just do it through inspiration. You've got to have artistic intelligence, to think your way through your art and plan, achieve, develop'.[3] He served as a Trustee from 2000 to 2007, was Chair of the Exhibitions Committee from 2007 to 2011, ran for President in 1999 and 2004, and sat on the Friends' Council from 2004 to 2014. He considers the latter to be of great importance as it is the continuous support of the Friends which keeps the Academy going – and in a position to expand in its 250th year.

Anthony and Mary have now been married for over 50 years and it is a combination of their ongoing love affair, their extended family and their domestic life that is the subject of Anthony's work: 'falling in love gave me the motivation and subject matter I needed – I would chronicle my relationship with Mary, our family and its continuing story'.[4] While much of his work reflects a happy and varied family life, latterly in a wonderfully bucolic setting in rural Cambridgeshire where reality and fantasy combine, he also deals with deeper and more sombre issues such as religion, alcoholism, divorce, illness and death. He takes pride in his feminist exhibition, **The Life and Death of Miss Dupont** (2017),

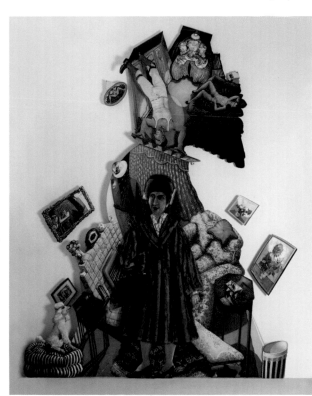

and has continued to challenge the art establishment through his use of figuration and autobiographical narrative. This is reinforced by the fact that, like Gilbert & George RA who revel in being outsiders, he is a Conservative which is decidedly 'uncool' within the current art establishment. But as Gilbert & George say, 'to be an artist you don't have to be a left-wing twit … If you're an artist and you're a Conservative, you're always the enemy in the art world … the art world is the problem'.[5] Anthony, despite often attracting the disapproval of some of his peers, feels exactly the same.

There is no separation between Anthony's paintings, sculptures and prints; for him, they are merely different ways of telling the same narrative. It is the common humanity, the shared experience reflected in his work, that helps explain his continuing popularity both in the UK and around the world (his works are held by many major institutions including Tate, London; Frans Hals Museum, Rotterdam; Dublin City Gallery; Museum of Contemporary Art, Tokyo and the Metropolitan Museum of Art, New York). Art, like music, crosses language and often cultural barriers – what Anthony paints is as accessible to his admirers in Tokyo as it is to those in London and New York, and fits in with his ambition 'to reach both the art expert and the layman'.[6] We all identify with family;

The Fur Coat: 'Hazana',
2005-14. AG574

either the one from which we have come or the one we have made. We have mothers, fathers, whether dead or alive, and other assorted relations, no matter how distant, and it is this that Anthony taps into to give his works universal appeal: the

'friendly interest of Green's human document is based on its visual directness and the decisive element of love which calls up a common response from all human beings'.[7] While the key to his work is undoubtedly Mary, he accepts that it is risky as he puts all his emotions, and those of his wife and family, on show to the world: 'my pictures do not judge; they simply mirror events. Inevitably, my family's frailties can only be hinted at. I don't want to hurt my family, they are who I am'.[8]

Anthony succinctly summarises his artistic career thus: 'Day 1, you make the decision to paint everything about your girlfriend; day 2, you get married; day 3, she gets pregnant; day 4, they lose the child; day 5, they dust themselves down and start all over again; day 6, have two lovely children, paint the in-laws, father and stepfather, and so you go on'. All the time, everyone is getting older; but whatever life throws at the Green family, whether they like it or not, they are a part of the continuing narrative and will all end up in the pictures.

Colourful Genes

F S Green was stylish, humorous, terrific company when he tried – but too often leaving his wife at home to go drinking with his rowing pals and male friends. My dad was intelligent and suffered fools not at all. All sons aim to be like their fathers. At the time of the divorce, we had terrible rows. Since his death in 1961, I have missed his wit.[9]

Like many of us, Anthony's personality, emotions, and character were formed and influenced by his family (especially his parents) and upbringing. His father's perfect school report from Junior School, which Anthony's grandmother kept framed and hanging on her wall, belies the man he became. He – Frederick (Eric) Sandall Green – later attended the Royal Polytechnic Institution in Regent Street, London but his parents did not have enough money to send him to university. Anthony describes his family being, at that time, 'lower, lower middle class', so his father went on to become an apprentice engineer in the aircraft industry, working at Vickers towards the end of the First World War, later becoming a master salesman with the Goodyear Tyre and Rubber Company who sent him to train and work in the USA. Soon after he returned to the UK, he left Goodyear and, in the late 1930s, set up on his own as the Regal Rubber Company at 345 Edgware Road, London W2. It turned out to be the biggest mistake of his life as in 1939 the Government withdrew the trading licences from recently registered tyre factories. Eric suddenly found himself in a civilian reserved occupation, working back in the aircraft industry for the duration of the War.

The Late F S Green,
1949. AG194

Anthony's relationship with his father was complex. He has stated in the past that he saw his father as 'a combination of Mr Pickwick and Idi Amin ... a dominant man who was mentally cruel; a loveable sentimental monster ... a failure'. Anthony was only 13 when his parents separated and he believes that 'the intense emotion of that period was the catalyst for my becoming an artist'.[10] Despite their

The Green family with teddy bear, c1944

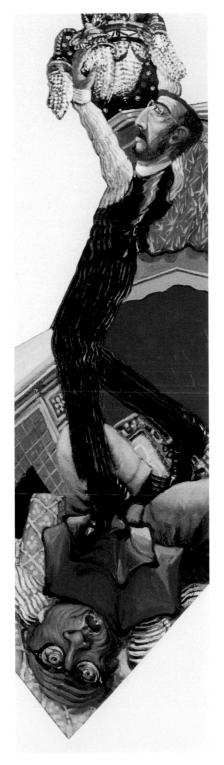

Anthony trampling on Dad. Detail from **Resurrection**, 1999. AG416

rocky relationship, Eric remained steadfast in his support for his son wishing to go to art school.

Over the passage of time, Anthony's feelings towards his father have mellowed. In *Resurrection: An Act of Faith (1996-99)*, Eric is depicted as being drunk, spilling his whisky from Anthony's silver christening mug, before being unceremoniously trodden upon, in an adjacent panel, as his son reaches for the freedom of the Slade. A further panel sees a more emotionally mature Anthony sitting in his father's chair as Eric moves towards Paradise, revealing Anthony's belief that we are all flawed but still get a chance of seeing the Light of God (represented by an intermittently flashing 1000 watt bulb in *Resurrection*). The rapprochement between father and son is more evident in a print encapsulating Eric's entire life. *An Enigma – The Artist's Father* (2003) is made up of an eclectic mix of original paintings (both old and new), real documents and family ephemera. The flexibility of printing offers more opportunity than paintings to make substantial use of the written word, something which Anthony has done both in *Enigma* and in many other prints. While some more traditional artists may claim that using writing in a picture is simply illustration, many contemporary artists like Bob and Roberta Smith RA (who includes great political tracts about art within society in his work) use writing/script/words much of the time.

In *Enigma*, the letters are from father to son and provide much of the background to this dysfunctional side of the family. The print covers Eric's whole life and demonstrates the opportunity available to the artist to play with time, which may be squeezed or stretched, where 'memories overlap, images blend into each other and different events can be painted in the same picture'.[11] Although the subject matter is essentially serious, there is still not only humour in the print but also, surprisingly, eroticism. The medallion shown in the centre of *Enigma* is part of an erotic pocket-watch that Anthony discovered among his late father's belongings. When the apparently respectable watch is opened, an enamel shows a very detailed copulating couple. It is revealing both that Eric possessed such an item and that his son is willing to share the secret.

The centrepiece of **The Life and Death of Miss Dupont** (Anthony's exhibition at the Royal Academy in 2017), is *The Fur Coat, 'Hazana'* (which means 'achievement' in Spanish and is the name of the house in which his mother, Marie Madeleine, and stepfather, Stanley Joscelyne, lived). He considers it to be a feminist work as it shows Madeleine to be a strong and independent woman despite years of living with an alcoholic husband which would have crushed many people. As Anthony has stated: 'My father carried his drink well, he never hit her, but he did mental cruelty very well. It would seem he loved Johnnie Walker more than sex'.[12] Madeleine finally reached breaking point and found the courage to divorce her husband, Eric, at a time when doing so was difficult for a woman and frowned upon socially, especially among the middle class. Anthony's extensive work is a mixture of a life-size painted figure with a real fur coat, drawings, watercolours and assorted family memorabilia. A distraught 13 year old boy's view of his parents' divorce is combined with the benefit of hindsight to create a unique take on marital breakdown, remarriage and its effects. It includes 'a bedroom scene … in which Stanley does a headstand in his underwear while Madeleine reclines naked on the bed. By juxtaposing this funny, private scene against his depiction of Madeleine's

public persona, the artist creates an uncomfortable image'. But, through the work, Anthony 'addresses a teenage boy's curiosity about his mother's sex life with disarming frankness, using a humorous note to tackle a difficult theme'.[13]

As with most of Anthony's work, there is an entertaining back story. Among the ephemera which make up some of the painting/sculpture, apart from the 1930's cellulitis-busting roller, there is also a set of false teeth that had belonged to his grandmother which Madeleine had kept when her mother had died. Madeleine's mother had, over many years, collected all the false teeth (with their gold subframes) from various dead family members, for her grandchildren to inherit. Anthony remembers a hilarious visit to his mother in her flat in Finchley, finding her sitting at her coffee table covered in false teeth. She was in a terrible state because she had lost her own set and was trying to find them among the hoard of her forebears' teeth then housed in an old jar. Anthony, being the dutiful son, worked through the gruesome pile by a process of elimination, getting his poor mother to try each ancient set before finally finding her own which fitted perfectly, much to the relief of both mother and son. In order to avoid a repeat incident he took the jar home with him where, like most things, it was carefully stored for future artistic use. The gold teeth have ended up screwed to a table and part of an exhibit at the Royal Academy being viewed by thousands of people. More bizarre and humorous is the lesser known fact that Anthony has quite literally included his mother in the artwork feeling that, since the exhibition is about Madeleine, she should be actually present. *Madeleine's Ashes: The Crystal Powder Bowl* (2015-17) is a small, painted, cylindrical pillar in which he has built a section, hidden just beneath the top of the pillar, to house his mother's ashes – something which he feels is akin to 'an ancient sarcophagus'.

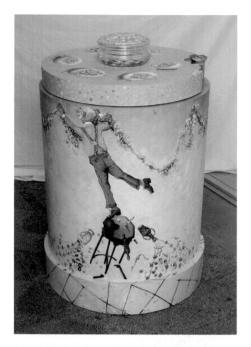

Madeleine's Ashes: The Crystal Powder Bowl, a Memorial, 2015-17. AG583

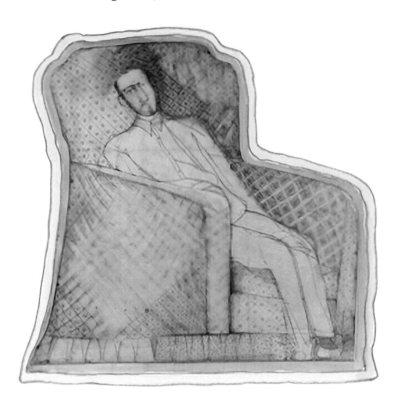

Detail from ***An Enigma: The Artist's Father***, 2003. PG17

The gold teeth, detail from ***Goodbye Madeleine – Bonjour Mado!*** 2004. AG457

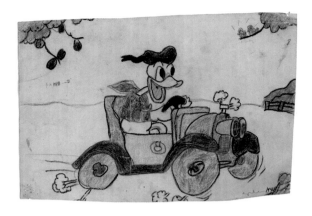

Donald Duck Speeding, 1948

Landscape (Hampstead Heath), 1955

Red Still Life,
1959-60

Ballet Dancer, 1960

The Early Years

Anthony Eric Sandall Green was born into what he refers to as a 'petty bourgeois', Anglo-French family on 30 September 1939 in Luton, Bedfordshire. Although there are no known artists among his forbears, the creative gene was clearly present in his grandfather who ended up as a Chef de Cuisine in London. Anthony's stepfather taught him how to work with wood, skills that proved invaluable when he started to create his unusually-shaped paintings. He has used board for over 40 years, usually hardboard supported by soft pinewood struts, glued and nailed on; in the last 20 years, however, he has switched to using medium density fibreboard (MDF).

Anthony's precocious talent was evident when, from the age of seven, he was able accurately to draw Disney characters freehand (he ended up 'wall-papering' his bedroom with them), admiring their expression, strength and image: 'My earliest influence is still with me. Disney, or rather his team, produced some of the most powerful images of the century, based on a lot of German popular imagery, of which they were the inheritors. And I am the direct inheritor of them'.[14] Anthony developed an early admiration for Van Gogh and, as a teenager, while staying with family in France (something he did annually from 1947), painted his version of a *Vase of Sunflowers* (1956-57) – the painting subsequently hung for decades on his appreciative mother's wall. He went on to study at the Slade School of Fine Art from 1956 to 1960 and was the youngest in his year group. At his interview with Sir William Coldstream much time was spent discussing Anthony's Cézanne pastiche, *Landscape (Hampstead Heath)* (1955), which Coldstream much admired – although he did ask the puzzled applicant why he wanted to go to art school at all as there was no future in it! Anthony's 'artistic heroes at the time were the European Expressionists, Soutine and Van Gogh, joined later by Rogier van der Weyden and Jan van Eyck'.[15] Such was his success at the Slade that he won a prize for his *Red Still Life* (1959-60), and the Henry Tonks Prize for Drawing in 1960 (for a life drawing of a ballet dancer), before being awarded a French Government Scholarship (1960-61) – swiftly followed by the Gulbenkian Purchase Award (1963) and a Harkness Fellowship (1967-69). On receipt of the latter, the Green family 'spent two years in the United States, living in Leonia, New Jersey, and Altadena, California'.[16] It was during this period that he relied more and more upon his visual memory to paint which resulted in his production of more complicated, large, figurative works.

Undoubtedly the most significant thing to happen to Anthony during his time at the Slade was meeting Mary. He was immediately struck by this tall, beautiful, and sophisticated woman who stood out from the conventionally unconventional

Vase of Sunflowers, 1956-57

female art students. They fell in love but, being children of their time, remained steadfastly chaste in the years prior to their marriage. While both were practising Christians – Anthony was a Catholic and Mary a Congregationalist – their abstinence had more to do with their shared Western bourgeois code of behaviour than any religious dogmas.

Anthony graduated from the Slade with a diploma in 1960. Degrees were not awarded at the time because art was not then considered an intellectual pursuit but rather as a top quality craft. While Mary finished her final year at the Slade, he took up his French Government Scholarship and went first to École des Beaux-Arts in Paris, and then on to 17 Rue Victor Hugo in Châteauroux where his French aunt and uncle gave him a room at the rear of their optician's business to use as a studio.

It was while staying in a not very salubrious room in a grimy hotel in Paris (Hôtel Centrale, Rue Bailly) that Anthony had to confront the familiar problem faced by art school graduates: if he wanted really to have a successful career as a professional artist, what direction should he take? What should he paint? After much emotional turmoil and self-analysis, he realised that he already had his subject matter: he would paint 'Mary, love, passion, sex'.[17] To put his decision within a wider context, 'in the iconic celebration of woman at large, he had found at least his essential subject'.[18] But Anthony later elaborated on his choice of subject matter in a characteristically forthright manner: 'I want to illuminate the world, and even stretch the preconceptions of those who look at my pictures. My concerns are universal, sometimes tasteless, frequently artless, but never dulling. I wanted to paint adolescence, bicycles, carpets, dog, Eric, failure, Greens, hair, irritation, Joscelyne, kisses, Mary, nasturtiums, optimism, penises, quiet, roses, sexuality, tenderness, undies, vice, walls, x-shapes, Yvonne and much much more'.[19]

Froggy Green

As a modern artist, entering the 21st century, all that I have that is unique is my individual humanity. My only claim is to be what the French describe as 'un petit maître' – a jobbing artist, but an original one ...[20]

Detail from **The Flower Painter**, 2006. PG31

Although often considered a quintessentially English painter, Anthony's French side is both important to him and never far from the surface. He grew up well versed in French culture. Since he was about 14, he has read French novels thanks to an enlightened schoolmaster who had suggested that he was wasting his time studying for O Level French. He was instead encouraged to concentrate on reading authors like Flaubert and Balzac, thus successfully improving his vocabulary learning rather through osmosis than by being taught.

Anthony was an only child and grew up in London surrounded by French women. When he went to his first school, aged 4, he did not speak a word of English. La Sainte Union in Highgate Road, London, was a Catholic Convent run by Belgian nuns and, owing to the Blitz, little boys were permitted to attend classes. Although bilingual, he is not a linguist and attempts to learn other languages have not been too successful. By the time

Detail from **5th Retrospective Painting With Flags**, 1961/1991/1993. AG338

'Hit the deck', detail from **Yvonne Lissac: Une Vie**, 2003. PG15

Anthony went to Highgate School in 1951, he was speaking English as his first language but, still being good at French, he quickly acquired the nick-name 'Froggy Green' – many of his friends from that era still refer to him as such, as did his old art master, Kyffin Williams RA (who taught him how to arrange his colours on a palette which he does in the same way to this day). Anthony learned to use it as a defence mechanism and soon took full advantage of it. At a time when visiting France was not commonplace, many believed that French men were completely sex-crazed and, often going to visit family in France, Anthony successfully played on that fantasy returning to school with his image greatly enhanced. He retains fond memories of his summer trips which invariably included taking tea with a friend of his aunt's. The result of these visits was the explicit *L'Heure du Thé: Argenton-sur-Creuse, Département de l'Indre: Jacqueline Planque* (1980): 'The French doctor's wife was gloriously promiscuous. I heard all sorts of troubling stories about the way she dispensed her favours and my mother was very worried that I occasionally used to go and take tea with her on my own. However, my aunt pointed out that as my pocket money amounted to about half a crown I was perfectly safe! … Nonetheless, although these social sessions were entirely proper, my fifteen-year-old imagination was not!'[21] The painting is now in the collection of Tate Britain but has not been put on public display for many years.

Anthony was brought up on stories of the 'good old days' and bought into them. He retains fond memories of sitting at the table with his French relatives, from the age of seven, listening to stories about living through the War and of the construction of his grandfather's ideal retirement villa. His relatives, on both sides, lived in homes that were simply bursting with collected items of every kind. They all kept photographs, especially of family weddings, because they were precious things, difficult to obtain and expensive. To Anthony, everything is sacred and he retains and re-uses as much as he can. This is evident in the print Anthony produced

The artist's palette

to commemorate his aunt's life, *Yvonne Lissac: Une Vie* (2003). Yvonne was absolutely obsessed with London theatre and the print was created by not only using hundreds of original photographs and written text but also by cutting up her 1920s theatre programmes with her personal comments inscribed on them, hence making the work even more personal. She had returned to France and married a Frenchman but arrived back in London in 1940. Her husband had been called up into the French army and they found themselves separated with Yvonne and their son living with her parents in London. The print shows Yvonne, under the eiderdown, in the spare bedroom at Lissenden Mansions while the bombs rained

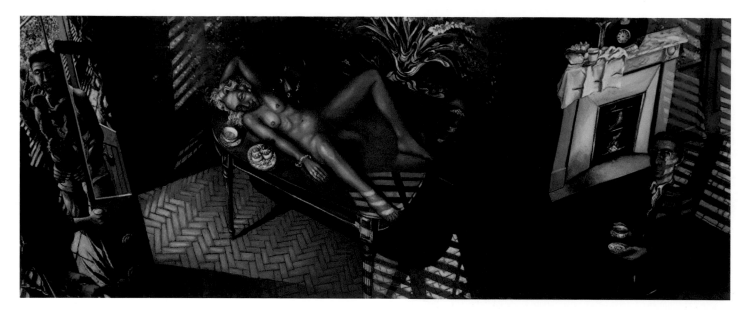

L'Heure du Thé: Argenton-sur-Creuse,
1980. AG266

down during the Blitz. It portrays a complete life from childhood through to her getting older, celebrating her Golden Wedding anniversary and, ultimately, suffering from Alzheimer's disease.

Casimir Dupont's medal

Another significant print in Anthony's oeuvre is one created to honour his French grandfather, Casimir Dupont – and the family heirloom, a chandelier. The same light fitting reappears in *Resurrection* and *The Young Artist Unknowingly Going To Heaven* (2000). Casimir was a French immigrant who had lived with his wife in rented rooms in Euston Road and Gaisford Street, NW5 from about 1900. Anthony produced a striking and comprehensive print in honour of his grandfather, *Homard Newburg* (2006), comprising original paintings, drawings, sketches, hand-written menus and photographs of houses, cars and Casimir's medal from the Association Culinaire Française. By 1912, Casimir was one of Escoffier's sous chefs at The Carlton in London and, by 1917, he was Chef de Cuisine at The Waldorf. Everything was going according to plan and he was looking forward to retiring to his new villa in Bergerac, France; unfortunately, at the last moment, the Wall Street Crash destroyed his investments and both returning home and retirement had to be postponed. Instead of Casimir dining beneath the grand chandelier, that honour went to occupying Nazi officers who smoked all his Havana cigars and drank their way through his cellar full of claret. The chandelier ended up in Anthony's Lissenden Mansions home and appears in several paintings including *Sixth Retrospective Painting* (1961, reworked 1991 and 2004) and *The Silver Wedding* (1986). Despite everything, Casimir led a long and happy life, and did end up finally retiring to France in 1952, not to his villa but to a flat in Châteauroux, l'Indre.

Casimir Dupont

Anthony's background and interest in French literature and history were enough to make him first look at French rather than English painting. He admits now that his thinking was very narrow at the time when he believed that French artists were far superior to their English counterparts: 'I was very impressed from my earliest artistic memories that my French inheritance encompassed L'École d'Avignon,

Villa Djanina, c1925

The Chef de Cuisine
with his medal,
c1917

Watteau, Fragonard, Renoir and Edward VII's Vie Parisienne. Aged 14, my first art books were colourful Skira publications on Lautrec, Cézanne, Modigliani, Van Gogh and Picasso'.[22] On being taken to see The Wallace Collection, he was attracted primarily to François Boucher and Jean-Honoré Fragonard. When later visiting the Louvre, he saw the great paintings of the post-Napoleonic period, especially Gustave Courbet's realist paintings which had a profound effect upon him: 'This for me was "real art" by "real artists": huge scale, exciting subject matter, fabulous atmosphere – they seemed to contain everything a picture should – Géricault's *Raft of Medusa*, Delacroix's *Death of Sardanapalus*, Courbet's *A Burial at Ornans'*.[23] Anthony realised that he faced a challenge: 'Could I celebrate my little world on a grand scale?'

The French use 'la petite histoire', which means literally, 'little history', to describe a certain type of art. It is not about major narratives, such as the Nazi occupation of France, but about an insignificant, nameless family in a little village, who are just trying to survive, have their own life, and create their own story. It is something that people outside the art world now take seriously with a lot being written about the history of ordinary people and their lives. The story that Anthony has chronicled in his art – what he calls 'little man art' – is very much 'la petite histoire'. He portrays both the life of the French peasantry and English petty bourgeoisie. He is not trying to appeal to the upper class because he himself has never been a part of that world. Although he has been criticised for saying this and accused of selling himself short, for him 'the truth is the truth'.

Historically, bourgeois art, like paintings of domestic scenes, became popular because of rising democracy; art was made locally for people like traders who wanted a picture of something familiar on their wall and this is, essentially, the category of painting into which Anthony's work best fits. His narrative is completely unimportant in the grand scale of things and, superficially, is of no interest to anybody outside his family. It has, however, turned out to be interesting to a wider audience as, while they are smiling at the image, people can simultaneously see themselves in the paintings. They identify with his art which often stirs memories of their own relatives and the various backgrounds from which they come. His pictures have a kind of tension within them that people find amusing and, each year, his admirers visit the Summer Exhibition at the Royal Academy to catch up on the next chapter in the Greens' story.

The Art of Faith

I know that I paint in a world of hope, love and redemption
which will triumph over the angst-ridden false gods of today
The future belongs to the young
Yesterday resurrection worked
Today it triumphs
Tomorrow it is certain[24]

Religion has always played a major role in Anthony's life and, despite it being unfashionable in the modern art world, it has continued to influence and be reflected in his art – but he is not as alone in this as it might first appear. Although their exact interpretations may differ, Tracey Emin RA has also stated, 'when I talk about God I'm talking about faith, belief, spirit, the forces which drive you on

if you want to carry on existing [and] if I thought this was "really it", I would be dead by now. It's like saying "Is there life after death?" Of course there is. I'm not going to spend the rest of my life arguing whether God exists or not. I'm going to get on with my life'.[25] When Emin's comments are juxtaposed with Anthony's mixed media *Resurrection*, the similarities between the two artists' attitudes to faith are striking.

Despite some people thinking that he is Jewish, Anthony was brought up a Roman Catholic, his mother's faith. His father did not care about religion and used to antagonise his wife by claiming that he was Plymouth Brethren (non-conformist and evangelical Christians). Anthony's English public school was Church of England, but admitted Catholics, Jews and Muslims, and it was there that he began to have religious doubts. He began to question Papal Infallibility and the idea that priests could do no wrong. His efforts to seek guidance from some priests in north London, resulted in them advising him simply to keep to the rules – as Anthony notes, 'there is nothing sadder than an ignorant priest'. It was meeting Mary, a Congregationalist (Christians who do not believe in religious iconography and count Oliver Cromwell as an adherent), which changed everything for him on the religious front.

Congregational Chapel, Pond Square, London N6 (left) and St Joseph's Roman Catholic Church, Highgate Hill (right), detail from **Resurrection,** 1999. AG416

The difference between the democracy evident in Congregationalist Church Meetings (which appoint Ministers) and the obvious lack of democracy in Roman Catholicism struck Anthony early on. He was attracted by the concept of having a direct relationship with God without the need for any interlocutor. He became a regular, church-going Congregationalist, and later a Church Elder in the newly amalgamated United Reformed Church from 1985 to 1992 (when he and Mary moved permanently to Little Eversden in Cambridgeshire). Although still a member of the Reformed tradition, Anthony now feels that his early upbringing in the Catholic Church made him realise that original sin, or imperfection, 'is a very useful commodity as it helps you to get through the day – you realise that everybody is imperfect, no matter how hard they try'. While, of course, he recognizes that there are some bad people in the world, he believes that 'you get more good guys than bad guys – the middle ground is where most of us live'. He is a very tolerant Christian who embraces those of other faiths and those of none, and happily spreads his beliefs in all sorts of directions. He likes the idea of a God – male, female, or transgender – who is beyond our understanding and hence believes that some humility among mankind would be appropriate. Although it sometimes irritates people, he chooses to believe that, when they die, both he and Mary will go to Paradise which he sees as far preferable to 'becoming fertiliser in the local garden centre!'

In terms of the influence of religion upon Anthony's art, his religious iconography is just another aspect of his work which is currently out of favour in the art world. He was brought up surrounded by religious imagery and spent the years immediately after his marriage travelling, with Mary, around 'Romanesque France – Conques,

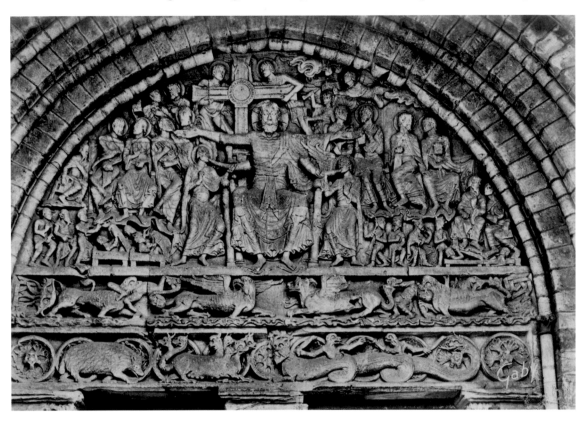

Tympanum, Beaulieu-sur-Dordogne, France, c1963

Autun, Moissac – and the sculptured tympana, the great lunettes above the doors, crowded with figures (originally coloured) affected him deeply. He marvelled at "how the narrative fitted into an architectural setting: that was the seed of my earliest shape pictures"'.[26] Naturally, he could not resist drawing what he saw and, in *Tympanum* (1964), he reproduced a complete narrative in a semi-circle. It shows Anthony not only in the central position of Christ but also, in the foreground, turning away to represent his realisation that he could not paint religious pictures in the late 20th century – 'a secular vision would have to do'.

One recurrent, surrealist image within Anthony's pictures is the floating, angelic form. In both his paintings and prints, angel-like figures may be seen gliding overhead: 'My floating figures come straight from angels in European painting. I was brought up a Catholic; angels seem to me a most wonderful human invention. … It may be that the fantasy-image, the floating image, is the retrenchment of the individual trying to rebuild spirituality, in the world which we've inherited. … The fantasy-image is a thing to which one retreats. It's a bit like a man going mad, except that one believes one stays sane'.[27] Yet others interpret the scenes as being 'reminiscent of daydreams, fantasies, or a vision of an alternative reality, free from the limitations of space and time'.[28]

Resurrection, one of Anthony's most ambitious works, was made to celebrate 2000 years of Christianity and toured 15 cathedrals as well as other religious buildings

and Dublin Castle before making its first commercial appearance at the 2003 Royal Academy Summer Exhibition. This striking and complicated work records the journey of Green family members, both alive and dead, to Gospel Oak Station to await their final trip by train to Paradise – a concept which is difficult to portray as it is an abstraction. The sculpture is a modern day equivalent of the didactic medieval floats that sought to encourage people to save their souls. In *Resurrection*, 'dreams and legends are discharged at us in volleys; bitterness and aspirations surface and take off as flyaway cut-outs, all the more poignant for being given so vehement an airing'.[29] Anthony has long felt that art has become too much about angst and the dark and violent brutality of life, resulting in people losing hope and feeling fearful. The reality is that most people lead ordinary lives with varying levels of happiness and sadness but are essentially good and that is the way to resurrection.

The sculpture provides an extraordinary vision, offering an insight into the artist's faith and views on life and death yet aims, overall, to give people hope. One of the most striking panels within *Resurrection* reveals the influence of an artist with whom Anthony is often compared and whom he admires greatly, Sir Stanley Spencer RA. Anthony's dead mother, aunt and mother-in-law are portrayed as rising from the drains, no longer old and infirm, clearly echoing Spencer's *The Resurrection, Cookham* (1924-27). About a year after making the sculpture, Anthony produced a series of prints to accompany it. While it undoubtedly made an impact, Anthony 'outing' himself 'to the artistic establishment as a card-carrying Christian' took courage[30]. It certainly hindered his search for a new gallery to represent him, and encouraged his critics to direct yet more fire in his direction; characteristically, however, he never wavered.

An angel ready for take-off, detail from *Resurrection*, 1999. AG416

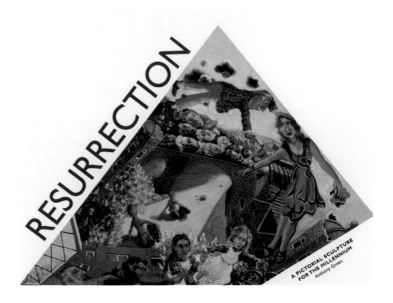

Resurrection catalogue, 1999

The Artist at Work

There are countless forms of narrative in the world ... there is a prodigious variety of genres, each of which branches out into a variety of media, as if all substances could be relied upon to accommodate man's stories. Among the vehicles of narrative are articulated language pictures, still or moving, gestures, and an ordered mixture of all those substances ... narrative starts with the very history of mankind; there is not, there has never been anywhere, any people without narrative.[31]

At the Slade, although he had done well, Anthony 'felt himself to be isolated ... at odds with the prevailing orthodoxies of abstraction ... and the dot-and-carry life-room objectivity' of the Coldstream method and the painterly sludge of the post-David Bomberg cabals.[32] He remained instead, for a time, under the artistic influence of Kyffin Williams and the School of Paris.

Much to his teachers' horror, Anthony derided their reverence for tonal painting. He felt that English artists' slavish production of such work had created acres of effctc art – 'keep white at bay!' He rejects the English concept of tone and touch in the middle of paintings, where it does not go too black or too white, a kind of tonality where middle tones are the goal. He likes it more clear-cut: 'if you don't want your picture to be too chalky, you use yellow as a substitute so that you get a golden glow coming off your pictures'. This makes his pictures, both paintings and prints, extremely colourful which, to English eyes, may be vulgar, but clarity of colour is typical of French painting – 'impressionist pictures are colourful and that's French, pure French'. The bold palette for which Anthony is known reflects both his own character and what he himself likes; he admits that 'the golden sun-drenched yellow dominates much of my work – I hate pasty pictures – where everything is mixed with white – chalky equals dull – white is the death of English art'.[33]

Anthony, having made his breakthrough decision on his choice of subject in 1961, stopped making drawings and painted, in high passion, straight on to the board. He was full of his love and desire for Mary and his wish to get back and marry her, so painting in this way (he could complete a work in about 2 hours) greatly appealed to him. By his own admission, however, the pictures he produced were 'absolutely appalling' – although about 30 key works did survive a later cull – but they did, conversely, provide the opportunity for a new beginning. One of the saved paintings was *Woman in a Corset* (1961-62) which, as often happens in Anthony's work, reappears within a later picture, *Fifth Retrospective Painting with Flags and Woman in a Corset* (1961 then 1991, finished 1993). This painting shows Anthony dreaming of the future, thinking what his wife might look like, and carrying her off. The original centre panel, where it all started, is raw emotion whereas the outer painting represents the continuation of the narrative.

While it is easy to see only the humour and the lighter side of life in Anthony's work, there is also a darker side. He is acutely aware, when recounting negative aspects of his life, that it is all relative and recognises he has not had to cope with living through civil wars, deprivation or other disasters. Within his tight-knit family, however, the still-birth of their first child (in 1963) was a tragedy and a major challenge, especially for Mary. It also had a telling effect upon Anthony and

Fifth Retrospective Painting With Flags And Woman In a Corset, 1961 then 1991, finished 1993. AG338

Detail from **Fifth Retrospective**

his work, and he found himself painting dark pictures and using a far less exuberant palette of deep browns, blacks and greens. His grief was part of the ongoing narrative and not to have included it would have resulted in an incomplete story and a lack of veracity. This period saw the creation of paintings that had a strong religious element, such as *The Black Crucifix* (1965), which 'records the almost unendurable loss but also the faith which sustained us'.[34] It was a genuine desire to make a Christian image but, with its explicitness and Anthony depicted as Christ, it caused outrage at the time. The story was taken up by the *Evening Standard* and made the front page of the *Daily Mirror* but, in an indication of changing attitudes, *The Black Crucifix* now hangs in St Helen's Church in Little Eversden.[35] It was only with the birth of Katherine in 1965 that this dark period in Anthony's life and career finally ended. In 2003, in much happier times, he produced a print which, with both humour and pathos, reflected his feelings at the time along with the benefit of hindsight. The title is revealing, *He Never Took His Eyes Off Us* (2003); it shows a painting of the young Greens, naked, rising upwards towards the eye of a giant, God-like Anthony Green. The backdrop comprises many pages from the Bible with a cross at the centre – the same shaped cross as in *The Black Crucifix*. On this occasion, however, there are no figures on the cross, just pages from the Bible – the 'word of God' – in line with Anthony's Protestant faith.

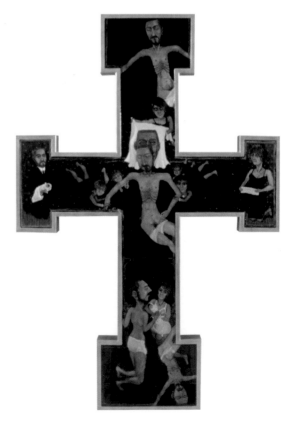

Black Crucifix, 1965. AG67

Further sadness has been caused within the Green family by two divorces (40 years apart) – his mother's and his elder daughter's – with all the associated emotional turmoil. But the message contained in the prints Anthony has made concerning his mother is certainly both loving and positive. *The Clock – Marie Madeleine! (versions I & II)* (2000 & 2003) is a mixed media creation (a variation

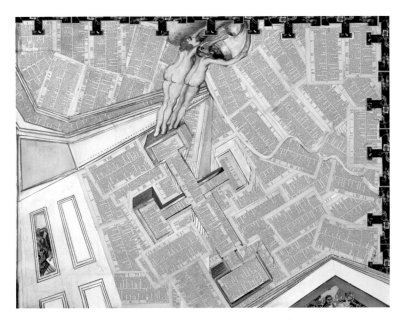

of which also appears in *Resurrection*) and, with a nod to the surreal, Madeleine is portrayed flying heavenwards out of the clock (which originally belonged to Anthony's paternal grandmother, Ada Green). In the print, the clock is surrounded by a mixture of photographs and paintings mapping out her life: 'Mum escapes, her love unfulfilled, to the tender yet passionate arms of a new husband equally scarred by life's vicissitudes. … Eric never recovered from the shock of Madeleine's leaving. His pride, well lubricated by alcohol, led straight to death at 61'.[36] A subsequent print, *Marie Madeleine (1910-2004)* (2005-09), again shows the unique opportunities offered by the medium of printing. Madeleine, resplendent in her fur coat – also seen in *The Fur Coat: 'Hazana'* (2017) – and complete with matching gloves and handbag, rises elegantly towards heaven, watched by her adoring son. In the

He Never Took His Eyes Off Us, 2003. PG19

background are a substantial number of shaped photographs showing her entire life from birth to death – a son's loving tribute to his mother – which would be difficult to replicate in a painting.

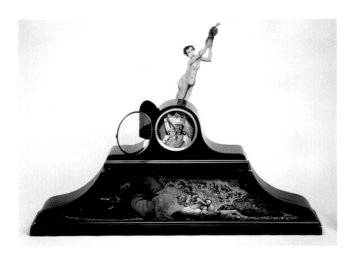

The Clock – Marie Madeleine (Version I), 2000. PG13

Critics and public alike comment most frequently on two aspects of Anthony's work: the shape of the pictures and his frequent portrayal of nudity and sex. To deal with the former first, he has always been interested in cognitive psychology which 'stems from his preoccupation with describing through painting … and he sympathises with scientific attempts to understand something of the processes by which we mentally construct descriptions of the world around us'.[37]

He was particularly influenced by David Marr's seminal work *Vision* (1982) as it accords with one part of Anthony's own vision of life and art, for he sees himself, above all, as an Everyman figure: 'Before I am a professional artist, I'm just a straightforward Joe Soap walking up and down the stairs and living the life. For me, that's the key. The non-artist sees the world perfectly well, can live a perfectly fulfilled life. He does not see like a Slade Student; he sees it a different way. This is where Marr becomes relevant; this business of objects in relation to function. When I say forks are forky, cloths are clothy,

Mary with baby Kate, 1965

shoes are shoe-y – the personality by which you recognise the objects in relation to their function – then I'm in the street along with other people. I know instinctively that's how people see the world, use the world; previous experience of objects, piled up in the memory bank. Too often artists dilute that, in the name of artistry and artifice'.[38] All of this led Anthony to re-think the shape of his paintings and to question the restrictions previously placed upon artists.

Adopting an 'innocent' viewpoint in his paintings, not an art school one, Anthony constructs his picture plane from a series of simultaneous narratives recorded within a single chronicle. He has a unique way of seeing the world and committing it to the picture which is evident in his readily identifiable method of creating irregular-shaped works. Early on in his career, his pictures were either square or rectangular, as is artistic convention, but he soon began to question the limitations of the form. He first started to create shaped pictures, like *Conception: Gospel Oak* in 1963, when he sought more artistic freedom perceiving that 'the pictures in my mind have no edges. I soon realised that my developing images did not have to be contained within the traditional rectangle … Ideally, I would like to paint a picture with an irrelevant perimeter. All the time I am getting closer, but I suspect it's an unattainable goal'.[39] The result was that he became 'a homespun visionary, the Stanley Spencer of the Pop generation. … He paints his cottage at Little Eversden, Cambridgeshire, and domestic life with his wife Mary with an obsessiveness that makes Spencer's relationship with Cookham look like a passing interest. But it is neither this, nor the Pre-Raphaelite palette, that makes his work so distinctive; rather it is his hallucinatory tendency to twist the very outlines of the paintings askew.'[40]

Shaped pictures, in Anthony's mind, should only be used to enhance the narrative: 'when I discard the right angle at each corner, I increasingly use a central drawn vertical line and a horizontal line to keep control of the developing composition. The fact remains that if the context of a painting does not lend itself to breaking out of the rectangle – DON'T! Eccentric shapes, just for the hell of it, are an act too far'. The form of the picture must be stopped where it most augments the narrative. But it remains a constant challenge as 'the images could be, and were, joined and cut up during their production but only if the developing composition merited the cut. This led me very far from the traditional rectangle. A picture need not be regular in shape – although deviation from this tradition produces endless and seemingly insoluble problems'.[41] The rule by which he lives, within his art, is that regardless of anything else, the narrative of a particular image defines its own shape of board in his mind's eye.

Anthony 'works in the media of both paint and print, using compound perspectives and polygonal forms, often on large irregularly shaped board. His use of unconventionally designed supports reflects the fact that, as the artist says, the pictures in his mind have no edges and do not, therefore, have to be contained within a rectangular form'.[42] Unlike the paintings where the boards may be cut into any shapes, when producing a print which is likely to be framed and glazed, there is the formal restraint of a rectangle into which the image and information are placed. But, within that rectangle, it is possible actually to start playing with irregular shapes, and to manipulate perspective. A tent, for example – as in *Fourteenth Wedding Anniversary: Our Tent* (1975) – has such a strong image simply as a tent shape when printing it on rectangular paper that the white borders become irrelevant.

In 1977, Anthony went to the South of France, on a commission to paint *Alexandra: Carte Postale – Souvenir de Castelleras* (1977). Nearly quarter of a century later, memories of that trip resulted in him producing a print titled *Côte d'Azur* (2003). This consists of a strong triangular shape, within which there is an image of Anthony and Mary but, outside that image, there is the artist looking in, thereby leading the viewer to question whether Anthony is part of the art or simply a voyeur. The print exists on different levels and is a riddle that needs to be solved. All the marks on the print relate to the edging; it may be a rectangle but there are large diagonals in the picture which act rather like scaffolding or guy ropes holding up another tent-like construction.

A brief look at Anthony's paintings and prints quickly reveals the importance of sex, nudity and eroticism in his work. It also shows humour and a disarming honesty: 'You asked me about the bureau painting [*The Bureau II – Afternoon Sun* (1999-2010)]; sex has been the central theme of my artistic obsession – it continues to the present. But, as the wilting tulips bear witness, even my attempts to revive with a watering from the Viagra blue jug won't work. Mary still looks terrifically vital but so did Mrs Bonnard in those erotic bathing masterpieces.[43] Mary has been painted exposed, naked, and semi-naked many times – as has a priapic Anthony himself in, among others, *The Pink Lounge* (1967 then 1971-74, 1991, finished 2005) and *The Fortieth Wedding Anniversary: Version I* (2001). There were paintings, such as *The Chinese Lantern* (1974), which showed Mary in an explicit and revealing position and, perhaps not surprisingly, her parents did not approve and refused to turn up to see them unveiled.

Alexandra in front of her painting, 1977. AG231

Anthony has frequently made the point, however, that without exception, the sex and eroticism depicted in his paintings and prints concern a married couple and are not gratuitously salacious in any way; indeed, 'we can peek into the Green's bedroom at any time. But God is also watching. None of these love-making scenes are pornographic. … these passionate love scenes become sanctified icons through Green's *bella maniera* (beautiful technique)'.[44] Mary is never seen or portrayed as being merely an object of lust, she is, rather, an object of love and a willing participant. She regards herself as being the vehicle by which Anthony may realise his vision. As well as being a loving wife and

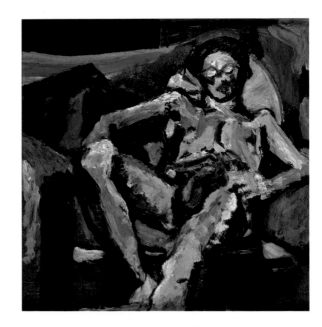

The Artist's Husband by Mary Cozens-Walker, 1962-63.

mother, she remains an independent, successful, and talented artist in her own right. Mary's book, *Objects of Obsession 1955-2011* (2011), shows each is the subject matter for the other. She is often as explicit and revealing in her art work as her husband. Her mixed-media creations have real bite and often deal with eroticism in a direct way, for example, portraying a naked and vulnerable Anthony in *The Artist's Husband* (1962-63), *Ravenna Dreaming* (2008), and *Forget-me-not* (1989-90).

Haircutting in the Studio by Mary Cozens-Walker, 2013

Perhaps because Anthony started producing prints later in life, the eroticism in them is not quite so pronounced as in the paintings but it still plays an important role. In *Pâtisserie* (2005), the female shopkeeper is depicted topless and, in another part of the print, the artist himself reaches for a pair of cakes shaped like female breasts (reminiscent of the surrealist

photographer Lee Miller's creation of and recipe for 'pink cauliflower breasts').[45] Eroticism is equally present in *Côte d'Azur* with 'Mary's nipple being tweaked and turned as if tuning an old-fashioned radio' and *Blue Pyjamas* (2007) and *The Blue Bedroom* (2013) where Mary is, once again, au naturel. She is also partially naked in *Tootsie, Don't Sit on the Quilt* (2012), but, touchingly, this print actually deals with the onset of old age, and focusses

Reaching for cakes, detail from *Pâtisserie*, 2005

Tootsie! Don't Sit On The Quilt, 2012. PG43

on her inability to do up her bra herself leaving it to her doting husband. It is based on a work called *Do Up My Bra Please* (2011). Anthony is nothing but honest, his exuberance about being in love with Mary is understandable but his willingness to portray their lives as age begins to catch up with them is revealing both of his character as a man and his veracity as an artist.

The Politics of Art

*Historically the art world has been fairly inward-looking because
it can operate as a closed circle. In fact, I feel like the art world
has a pretty tense relationship with popularity. The circle of artists, museum,
critic, dealer and collector did not necessarily need the
good opinion of the public. Now, I think that it's different, and
that popularity may affect the course of art history.[46]*

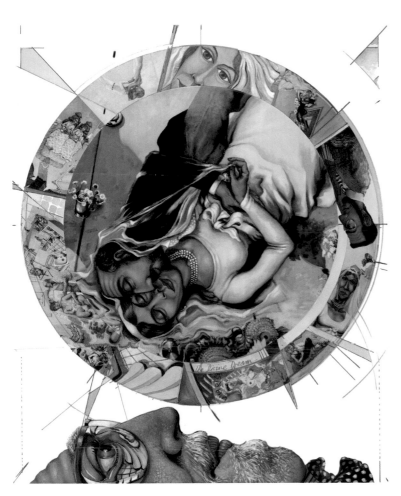

The Divine Dream, 2003. PG25

After deciding that all he really wanted to do was paint about being in love with Mary Cozens-Walker – 'it had nothing to do with art at all' – Anthony realised that he had to make substantial changes to the way he worked. His first task was to break from the influence of the Slade: 'I'd already thrown the Slade drawing skills out of the window. I knew instinctively that if I wanted to be me, I had to stop drawing like all those English artists who'd taught me at the Slade'.[47] He then took what had already been done in art as ammunition for his narrative and added on to that the various twists and turns of art history from the last 10,000 years, which he had been taught, at the Slade, by art historian E H Gombrich – and then simply pillaged it to enhance his narrative. He had an instinctive feeling that he was on the right track despite it being 'all the schmaltz that proper artists would reject as not suitable for proper art. But it isn't, it's basic stuff, it's what makes the world go around'. This has resulted in him unintentionally creating enemies in the art world as he has remained resolute in his determination not to change from being a chronicler painting chiefly his family, love, sex, embarrassment, apprehension, fear, and failure: 'Art is merely a way of conveying the story and that upsets people because a lot of people now actually do art about art. At present, we have a lot of art that is going on but which nobody understands unless you are in the club. It doesn't devalue it, it is just another way to do art'.

He has pursued his unwavering course for over 50 years and has no intention of stopping; he is only now slowing down slightly because of old age yet still asserts 'that is my story, and I do not retract anything from the narrative'.

There has always been pressure, of which Anthony is acutely aware, to paint rasping, social satire. He could metaphorically disembowel himself, concentrate on the dire condition of the world and use excessively black and red paint in his pictures, echoing the French Realists. Rather than struggle in a milieu where he does not feel comfortable and which is not his forte, he keeps to his vision leaving the anguish to other artists: 'we are not all doomed, everything is not unravelling, for most people life just goes on'. Despite his fears and anxieties, and his sense of inadequacy, he remains a born optimist. Anthony's pictures are full of humour and jokes. He deliberately tries to make them witty because the human condition is funny. He puts it characteristically succinctly: 'if you want to a be real artist, be prepared to stand, metaphorically, in the middle of the street, on market day, in your underpants and be laughed at. If you can't take it, adopt another career'.

A good example is the *The Divine Dream* (2003) which celebrates the Green's Silver Wedding Anniversary and shows how his work – and depiction of Mary – has developed over the decades. Anthony and Mary are pictured in the centre surrounded by many illustrations of their life together. It starts with *La Mariée* (1961) in the style of Chaïm Soutine (painted in France), followed by breakfast in bed at 17 Lissenden Mansions (painted in London), through to playing at being angels in the skies over Little Eversden, and ending with being warm and wet in a yellow bathroom with a clear nod to Sandro Botticelli's *The Birth of Venus* (mid 1480s). There is, in addition, a periphery of Van Gogh's sunflowers – 'some might say that picture making is king'.

Anthony's decision, in the late 50s and early 60s, to paint figurative and autobiographical pictures was professionally risky as it is had been out of fashion for several decades and was disapproved of by many avant-garde artists. There was, at the time of his decision in 1958-60, a multitude of different languages of art extant in the West culminating in Abstract Expressionism, the dominant development in art at that time. The Cold War was also a cultural war with both sides seeking to influence the public in the hope that it would encourage disaffection with their respective political hierarchies. Figurative art was produced by officially sanctioned artists in the Soviet Union and Eastern Bloc and was considered yesterday's vision, while the Free World was a place of liberation where Abstract Expressionism was pursued by artists like Mark Rothko and Jackson Pollock. It was a battle between social realist painters and Modernists. Figurative artists in the West were tainted and their art was deemed irrelevant by the patronising avant-garde attitude to much figurative art at that time.

'La France' au 17 Lissenden Mansions 1939-44,
1981. AG270

Detail from *Vélo*, 2007. PG34

Mary looking prettier!

Otto Dix, a successful painter between the wars, whom Anthony greatly admires, was deliberately humiliated when applying for a job in West Germany after the War when he was asked to explain who and what he was. Some in the West saw him as an embarrassment, yet now he is regarded as a cornerstone of German Figuration and German Expressionism. There are significant links between Anthony and Dix in that the latter 'tried to paint real hands and feet and nipples and machine-guns. He felt the power of the object' and like Anthony 'drew a face first with expressionist abandon, but then he would overlay it with supplementary information – nose, eyes, mouth … '. What the two artists share 'is an almost defiant commitment to the material world, no matter how hideously or heavily it weighs'. But where Dix 'always retains the sting of social criticism', Anthony claims truly to 'applaud these rooms cluttered with appalling objects, the lives lived in them'.[48]

Anthony, like Dix, is an outcast, feeling that in artistic terms he lives in a 'Stalinist' regime and, like Trotsky, has been removed metaphorically from all the photographs and become a non-person. It is puzzling, for example, that his recent considered and interesting show at the Royal Academy, **The Life and Death of Miss Dupont,** ran for several months and was seen by hundreds of people on a daily basis, yet there was not a single serious review – the strong sense is that 'it's political: by not writing about you they cross you out of the narrative'. The problem is that the exhibition is about a middle-aged woman who meets a middle-aged man from Brighton. Both are unhappy but eventually make it through, get married, and have 16 wonderful years before he drops dead. It is the kind of life that affects many people hence the positive public reaction to it – but in the current climate, it is not considered to be modern, relevant, or in any way avant-garde.

In the 1960s and 70s, the prevalent fashion was not to paint women as being pretty. When, at the time, people questioned Anthony as to why he always painted Mary looking so unattractive, he replied that it was the result of him being intimidated by the then politics of the international art world. He was worried that, if he had painted pretty pictures, he would not have not stood a chance of succeeding as a contemporary, cutting-edge artist and would not have been taken seriously by his peers. As a result, Anthony was unable to paint Mary as she really was and, as he now freely admits, at the time he simply did not have the skills to do so as he had never been taught them. He had, however, been taught to be objective in his art. The aim was to create something that would be described as a beautiful drawing as opposed to a beautiful girl. He needed to be serious and, more significantly, his art had to be seen to be serious. Although he always painted Mary as being plain, there were coded signals in his pictures (such as the red lips associated with 'painted ladies'). In addition, he could not totally suppress his inherent sense of humour. He recalls that while in Manhattan, he had been sitting, on a bus, behind a woman wearing curlers and he had been able to look through the little tunnels to the sky beyond. It had quite an impact upon him and he had rushed home to inform Mary that he was going to do a series of paintings with curlers. The result was *Mary Green* (1968), *USA II* (1968) and *Altadena, Margaret Croxford's Dream* (1968). Although, in the paintings, Mary is still depicted in an unattractive manner, Anthony's aim was to amuse his viewers by satirizing English snobbery: to a middle-class British man in the USA, a woman going shopping in her curlers was quaint but, in England, it would have been considered 'common'. It was only as the years passed and artistic conventions changed, and as he acquired more courage and skill, that he began to make Mary look prettier.

Although Anthony has never wavered during his long career he has, perhaps inevitably, had some doubts about the course he has taken when he has witnessed other artists acquire greater fame and fortune than him while he has often been ignored for being a reactionary. In spite if it all, throughout the 1960s, 70s and 80s, he was considered a successful, if eccentric and idiosyncratic, artist and was well reviewed until a new and revolutionary way of producing art (often using technology) arrived with the Young British Artists (YBA). As a result, Anthony and artists like him were increasingly ignored and soon became passé. The YBAs burst on to the scene in the 1980s with everything focussed on Damian Hirst and seven or eight similar artists. The subsequent aesthetic was for art to be conceptually based; consequently, Anthony suddenly represented everything from which they were seeking to escape. Formerly, his work had received widespread coverage from art critics, like William Feaver of *The Observer* and Richard Cork of *The Times*, but their younger successors were far more interested in the new art movement. Anthony was careful, over the next three decades, not to voice his feelings in public because he knew he would have been ridiculed – but he was not the only one who feared for the future of figurative art. David Hockney, always so relevant in the art world, has often spoken about how any form of representational art was dismissed in the early 60s and, in the 1980s, he had attacked Tate Modern for not displaying works by figurative artists. Anthony, not daunted by the isolation, continued down his chosen path retaining absolute faith in the value of narrative and figurative art; now he, like many other figurative artists around the world, waits patiently for the artistic wheel to turn and for fashions to change.

Soon after leaving the Slade, Anthony had the good fortune to be introduced, by 'Andrew Forge … one of Green's more sympathetic tutors at the Slade', to Alex Gregory-Hood 'and Diana Kingsmill, founders of The Rowan Gallery. They took Green on and their business and personal relationship lasted for over 30 years'.[49] It a curious coincidence that, in 1956, when Anthony was a Lance Corporal in the Combined Cadet Force at Highgate School, the annual inspection was carried out by none other than Gregory-Hood, then a Lieutenant Colonel in the Grenadier Guards – neither knew at the time of the happy and successful relationship that lay ahead. When Gregory-Hood retired in 1990, however, Anthony's narrative style was out of fashion and he found it very difficult to find a gallery to represent him, especially as many saw his work as being too personal and they were uncomfortable with the religious theme evident in some of the pictures. Anthony has always felt both grateful and fortunate that he has had The Royal Academy to rely on and, for the last 52 years, has exhibited at the annual Summer Exhibition. In addition, a brave decision to operate independently with the help of Whitcombe Associates enabled him to continue to follow his own path. This resulted in 15 years exhibiting successfully around the UK, most notably at The Richmond Hill Gallery in Richmond upon Thames, John Davies Gallery in Gloucestershire, The Roger Billcliffe Gallery in Glasgow and The Fine Art Society and Art Space Gallery in Central London. He has, latterly, found a home with a kindred spirit and admirer at Chris Beetles Gallery in St James's, London.

Combined Cadet Force
inspection, 1956

Lance Corporal A Green,
2003. AG452

The Prints

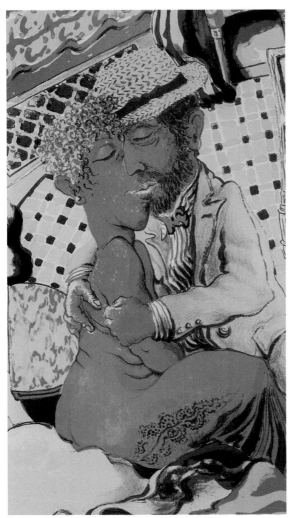

In the past, Anthony Green had successfully adopted traditional methods of printmaking such as silkscreen and lithography. His most recent prints use the giclée/inkjet process, to create unique compositions using a wide range of media including oil painting, watercolour, oil pastel, decoupage, pencil, and collage, combined with reproduced details of older paintings and drawings, family archives, and other personal ephemera.[50]

While at the Slade, Anthony did make a few prints which were derivative and made in Soutine's 'language', but he later destroyed them. He was not attracted to the process of creating prints, having no idea as to subject matter since he had not yet made the key decision to be a narrative painter. It was only later, when he had returned to teach at Highgate School, that he was tempted to try again. His first print *Kissing Couple* (1962-63) was strongly influenced by the contemporaneous and highly erotic gouache *The Ravisher* (1962-63). Bored while invigilating a drawing class – 'only boys really hopeless at cricket managed to put their names down for "art" instead' – he carved into a piece of cherry wood. He printed the woodcut with some sticky ink just to see what would happen but quickly realised that unfortunately it was not very good – it was swiftly put away and never exhibited.

Detail from ***Kiss At The Ritz***, 1988. PG2

After 1963 Anthony made no prints concentrating instead on oil painting. It was only in 1988 that Curwen Press invited him to make some lithographs, one of the first being *Kiss at the Ritz* (1988). On their way home from celebrating their Silver Wedding anniversary in Venice, in 1986, the Greens had stayed at The Ritz for a weekend of sheer indulgence. By the time Anthony came to make the print, he had already done a series of apposite oil paintings and watercolours which he was able to use as well as the original photographs he had taken at the hotel. The resulting lithograph has a distinctive look and a deliberately strong palette chosen by Anthony, borrowing from German Expressionism by using colour for eroticism. In *Kiss at the Ritz*, the figures are against the light so making Anthony's and Mary's faces mauve – it is not naturalism, it is simply using colour for effect to raise the temperature of the image.

Tent sketch, 1989

In the 1970s, Anthony had created several paintings of tents which he utilized to produce a new print with a unique interior, the result being *Mary Cozens-Walker's Box and Anthony Green's Tent* (1989). This lithograph was created by drawing directly on to zinc plates and doing the colour separation in the studio. It had to be done on two plates as the print is so large, and the line in the middle is kept deliberately visible: 'The publication of these images marks the culmination of the Artist's first explorations into the processes and possibilities of lithographic printmaking … The success of these first three images adds yet another dimension to an already fascinating artistry'.[51]

Anthony's decision to continue producing prints was made because, although he is a professional artist who sells paintings for a living, he only creates six or seven a year which are inevitably looked at by a relatively limited number of people. When he made his first prints with Curwen, he found that his coterie of collectors suddenly increased. It was a deliberately democratic decision as it allows for the production of more than one image and, with a limited edition of 25 or 50, he can share a substantial part of 'Green's World' at a more modest price and reach a wider audience. It was no longer just affluent people who bought his paintings; the prints were available to people who loved seeing his work but could not afford an oil painting. Since 1988, making prints has become a part of his annual artistic output and he has continued to produce one or two every year, often showing them in the Royal Academy's Summer Exhibition. Anthony considers all his previous work to be like a medieval pattern book (used by artists like Albrecht Dürer to reproduce images they had not seen first-hand) and uses his existing paintings to create prints that link him to the past. He relies on the past to move forward and believes that none of us are completely free but all are burdened by our own psychological and cultural baggage.

Anthony uses a variety of techniques to produce his prints and is unconcerned about keeping to any specific method. Over the decades, nearly all his paintings and sculptures have been professionally photographed, with special care being taken to ensure the colours are true to the original. To make the prints, he cuts up the photographs with a scalpel and then pastes them on to the paper before applying watercolour, oil paint, oil pastel, pencil, collage of black and white photos, newsprint and even real objects. He summarises his process thus: 'compositional experiments are made possible by recent developments in photographic colour separation, digital scanning and especially the new technologies of inkjet printing. … components are temporarily glued together, blue tacked, fixed and masking taped together then scanned and printed in small editions. Afterwards, they are dismantled and returned to my archive boxes and drawers – only the print remains'.[52] There are no set rules as far as Anthony is concerned and, as ever, so long as it fits the narrative and fits the image, anything appropriate may be added to make up the print: they are, above all else, fresh narratives.

When Anthony wanted to create a set of prints to accompany *Resurrection*, he started with screenprints made by Kip Gresham, Master Printer at The Print Studio in Cambridge, who is 'particularly proud of the work his studio produces when it seems atypical – or an extension – of the artist's work in other media, as is the case of Anthony Green'.[53] Although Gresham was enthusiastic about the project, unfortunately he fell ill and had to withdraw after producing only four prints. Anthony made the difficult decision to go it alone and used inkjet printing which allowed him to tell a complicated story involving a lot of found imagery.

Detail from *Railway To Heaven*, 2001. PG14

He was delighted to discover that, using a computer, he could create full colour prints completing the whole process in one go. It enabled him to produce virtually anything he liked with letters, photographs, quick drawings and written information all being put into this 'glorious trifle'.

Anthony often uses soft-ground etching, something that he was inspired to do by a fellow Royal Academician: 'Over 20 years ago, Norman Ackroyd RA encouraged me to make soft-ground etchings, posting the prepared copper plate to me in a jiffy bag, I drew my vase of flowers – *Vase of Flowers* (1995) – in pencil on the tissue paper which marked through to the soft varnished surface. I posted my effort back to Norman who proofed the plate and forwarded it for my approval. The acid-etched drawing looked most promising on the creamy white paper. In our phone conversation, we decided on an edition of 90 and, as Norman said "we are breaking new ground, etching by post!" Later, some of the flower etchings were hand-coloured by me. Two further prints, *Lovely* (1995) and *Splendour* (1995), were drawn and etched under Norman's supervision in the Royal Academy Schools' print studio'.

An Enigma: The Artist's Father, 2003.
PG17

The Narrative Continues

Illustration is a word I am rather wary of, because I was always brought up to believe illustrators were not proper fine artists. I do not think I mind ... Yes, I will be an illustrator too. Perhaps I am an Illustrator on Monday, a Narrator on Tuesday, a Chronicler on Wednesday, a Social Realist on Thursday ... All those things are my concern.[54]

Anthony has been described as undergoing 'conventional art school training, but with highly unconventional results'.[55] Christopher Le Brun, President of the Royal Academy, on opening **Anthony Green RA – Among Royal Academy Artists and Friends** at Chris Beetles Gallery in London in 2018, praised Anthony's personal artistic style, his unique and sustained vision and, above all, the humanity and passion which are so evident in his work. Anthony shares this humanity with another Royal Academician, Tracey Emin. Both artists portray sex in their works and some of Anthony's paintings, like *The Chinese Lantern, L'Heure du Thé: Argenton-sur-Creuse* and *The Fortieth Wedding Anniversary Version I*, are as explicit as Emin's work. But, just as Anthony's portrayal of sex has a deeper role revealing his passion, so with Emin things are not always what they seem: 'People think my work is about sex, but actually a lot of it is about faith ... I think that having faith is so important and yet much of the world lacks faith'.[56]

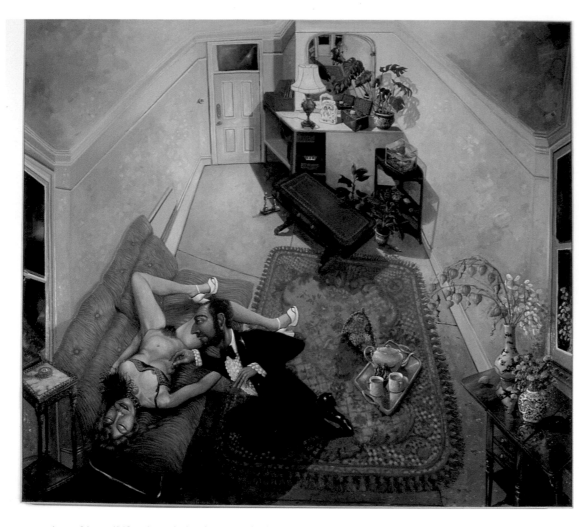

In spite of her difficult upbringing, Emin has clearly succeeded, becoming Professor of Drawing at the Royal Academy between 2012 and 2013, and Anthony is proud of his role in helping to get her elected as a Royal Academician. She has a great gift for drawing and for making extraordinary textile embroidery. One of her signature artworks is *Everybody I have Ever Slept With 1963-1995* (1995), also known as '*Tent*', which includes not only the names of all the people she had slept with but also all the people she had been brought up with and had loved – and the people who had disappointed her. While some people have been offended or embarrassed by her work, her art is real and reflects her life. Although Emin and Anthony have very different backgrounds and experiences, they share the same desire honestly to share their unique narratives, good and bad, through their art.

Anthony's 'pattern book' of paintings, sculptures and prints is now substantial – and is being added to and developed all the time. He is still pursuing the goal he set earlier in his life: 'what I am really edging towards is an understanding of an artless image. I've been aware of this quest ever since I started my life as an artist in the early sixties. Albeit I did it in a very ham-fisted way, I knew it in my bones that I was going for something new. This business of the non-art look of things is my way of trying to make the next step forward. I try to put myself in the heads of people who haven't been, so to speak, sullied by the self-conscious practice of modernism. I know there's going to be an alternative convention. I've been concerned for a long time with pictures in my mind. I feel one's got it within one already, and it's simply a matter of organising it'.[57]

The recent Green print, *Anthony Adoring Mary* (2015-17), comprises a set of two prints (etching with watercolour and pencil) showing an older Anthony sitting dreaming of his younger self flying over to 'ravish' Mary. In many ways, things have come full circle as, at the beginning of his married life and artistic career, he had painted *The Ravisher* but, while the subject matter is the same, the latest version is both more sophisticated and subtle. It would be easy to think of the print as simply personal and nostalgic but Anthony is being both honest and a realist; the sense of crisis evident in this and his other paintings and prints 'comes from a critical spirit. And it is this spirit which keeps this happy autobiographical drama from vulgar, romantic sentimentalism and makes it appeal as painting'.[58]

Le Peintre A Contre Jour Aux Immortelles, 2016. PG51

Some have been tempted to dismiss Anthony's work as being too narrow, too domestic, or simply just lightweight and humorous but there is far more to it than that as, 'under the humorous mask Green is mounting a single-handed assault on the walls of Modernism, and making some quite appreciable dents'.[59] He has a unique vision and a 'determinedly self-specific imagery.'[60] There is also the ambiguity that surrounds his relationship with his audience. While we look at his paintings and smile, perhaps, 'rather than our laughing at Green, he, behind the childlike masquerade of his pictures, is laughing at us.'[61] This may well be the case but it is more likely that Anthony's passion to chronicle his story and his innate humanity towards his fellow human beings mean that, if he is laughing at us, it is done not in a malicious way but with a characteristic twinkle in his eye. The story is not over yet.

[58] Hayashi, 'Sacred Icons of the Everyday', *Anthony Green 1960-86*, 41.

[59] Hyman, 'Anthony Green', *Anthony Green 1960-86*, 31.

[60] Julian Freeman, *British Art: A walk round a rusty pier* (London: Southbank Publishing, 2016), 257.

[61] Lucie-Smith & White, *Art in Britain 1969-70*, 146.

Chronology

1939 Anthony Eric Sandall Green born in Luton, Bedfordshire, on 30 September.
1939-90 Lives at 17 Lissenden Mansions, London
1943 Attends La Sainte Union Catholic School, Highgate, London
1947 Attends St Aloysius Catholic Junior School, Archway, London
1951-56 Attends Highgate School, London
1954 Eric and Madeleine Green (Anthony's parents) divorce; Madeleine Green marries Stanley Joscelyne
1956-60 Studies at The Slade School of Fine Art
1957 Meets Mary Louise Cozens-Walker (born 11 August 1938)
1960 Awarded the Henry Tonks Prize for Drawing
1960-61 French Government Scholarship to Paris
1961 Frederick (Eric) Sandall Green, Anthony's father, dies
1961 Marries Mary Cozens-Walker
1962 First solo exhibition at the Rowan Gallery, London
1962-90 Exhibits at the Rowan Gallery, London
1963 Birth of stillborn baby girl
1963 Gulbenkian Purchase Award
1963 First woodcut print: *Kissing Couple* (edition of 5)
1964 Elected to The London Group
1965 Katharine (Kate) Charlotte born
1966 First exhibits at the Royal Academy Summer Exhibition
1967-69 Harkness Fellowship to the USA
1969 Stanley Joscelyne (1893-1969), Anthony's step-father, dies
1970 Lucy Rebecca born
1971 Elected an Associate of the Royal Academy
1972 Purchases cottage in Little Eversden, Cambridgeshire
1973 Produces controversial poster for Royal Academy Summer Exhibition
1977 Elected to the Royal Academy
1977 Royal Academy Summer Exhibition, Exhibit of the Year (*1958: Hall of Mirrors*).
1979 BBC *Arena* film: *Now and Then: Anthony Green*
1982 BBC *Human Brain – Seeing*
1984 *a green part of the world,* by Anthony Green and Martin Bailey (ed), published
1987 ITV South Bank Show film: *Some Reflections on the Life and Times of Anthony Green RA*
1988 Invited to produce prints with the Curwen Gallery
1990 Moves permanently to Little Eversden, Cambridgeshire
1991 Elected a Fellow of University College, London
1994 BBC East, *Sheridan Morley meets Anthony Green RA*
1995 Awarded 21st Century Association Prize, Osaka, Japan. Produces works with the Print Studio, Cambridge.
1996 Shortlisted for the Jerwood Painting Prize
1997 BBC Omnibus film: *Anthony Green RA, 57 Up*
1998 Elected an Honorary Member of the Royal Society of British Artists
1999 Serves as Senior Hanger of the Royal Academy's Summer Exhibition. Stands, for the first time, as a candidate for President of the Royal Academy
1999-2001 UK tour of *Resurrection: An Act of Faith* (1996-99)
2000-07 Trustee of the Royal Academy of Arts

2001-11 Serves on the Council of the University of Buckingham

2002 Elected a member of the New English Art Club. First inkjet prints

2003 *Anthony Green RA: The Works!*, Opus School of Textile Arts (TV film)

2003 Featured Artist at the Royal Academy 235th Summer Exhibition

2004 Marie Madeleine (née Dupont) Green, Anthony's mother, dies. Stands, for a second time, as a candidate for President of the Royal Academy

2004 Elected an Honorary Member of the Royal Institute of Oil Painters

2004-14 Member of the Friends Council of the Royal Academy of Arts

2007-11 Chair of the Royal Academy's Exhibitions Committee

2008 Shortlisted for Threadneedle Figurative Art Prize

2010 *Anthony Green RA – Flowers, Clouds, Corsets and a Cactus* by Anthony Green, published

2010-17 Prints donated to the University of Buckingham

2011 *Objects of Obsession 1955-2011 – A Pictorial Autobiography* by Mary Cozens-Walker published

2011 Awarded Honorary Doctorate by the University of Buckingham

2012 *Resurrection: An Act of Faith* (1996-99) exhibited at the Greenbelt Festival

2013 'An Evening with Anthony Green RA', Wolfson College, Cambridge

2014 Becomes a Senior Royal Academician. BBC Radio 3 – *Private Passions: Anthony Green*

2015 Elected an Honorary Fellow of Wolfson College, Cambridge

2017 *Anthony Green: Painting Life* by Martin Bailey published

FAMILY TREE

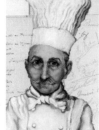

JEANNE
LE BRETON
(1882–1963)

CASIMIR
DUPONT
(1880–1961)

FREDERICK ARTHUR
GREEN
(1868–1934)

MAURICE
LISSAC
(1907–2005)

YVONNE
(1907–1997)

MARIE-MADELEINE
(1910–2004)
m. (i) 1933–54

FREDERICK (ERIC)
SANDALL GREEN
(1899–1961)

MARIE-MADELEINE
(1910–2004)
m. (ii) 1954–69

STANLEY
JOSCELYNE
(1893–1969)

ANTHONY GREEN
(1939–) m. 1961

MICHEL LISSAC
(1932–)

ISABELLE NUNEZ
(1933–)

CHRISTINE LISSAC
(1959–)

MARC LISSAC
(1964–)

SYLVIE BAILLON
(1966–) (divorced)

KATHARINE (KATE)
CHARLOTTE
(1965–)
m. (i) 1994–2010

ANDREW
HOWARD
(1968–)

KATHARINE (KATE)
CHARLOTTE
(1965–)
m. (ii) 2013–

MARTIN
HOAR
(1961–)

ALEXANDRE
LISSAC
(1996–)

JESSICA GREEN-
HOWARD
(1994–)
(adopted 1995)

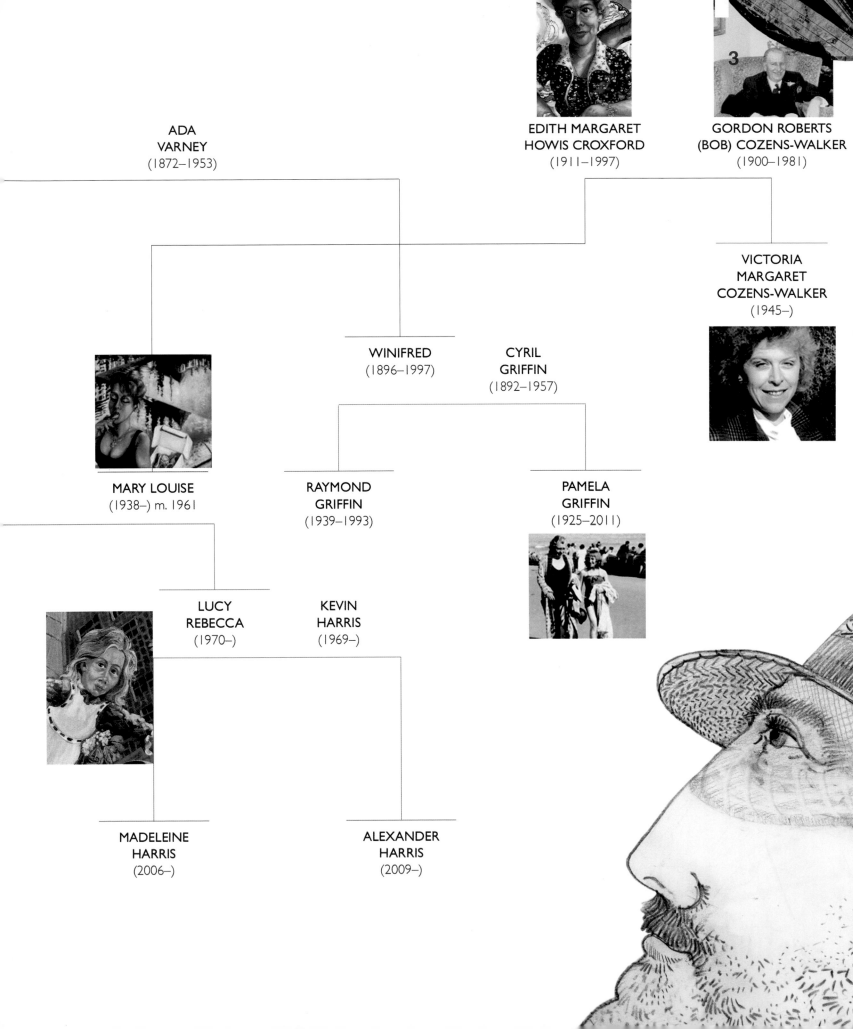

ADA
VARNEY
(1872–1953)

EDITH MARGARET
HOWIS CROXFORD
(1911–1997)

GORDON ROBERTS
(BOB) COZENS-WALKER
(1900–1981)

VICTORIA
MARGARET
COZENS-WALKER
(1945–)

WINIFRED
(1896–1997)

CYRIL
GRIFFIN
(1892–1957)

MARY LOUISE
(1938–) m. 1961

RAYMOND
GRIFFIN
(1939–1993)

PAMELA
GRIFFIN
(1925–2011)

LUCY
REBECCA
(1970–)

KEVIN
HARRIS
(1969–)

MADELEINE
HARRIS
(2006–)

ALEXANDER
HARRIS
(2009–)

Previous page: Artist in his studio with a six sheet cartoon for *The Happy Morning* — mixed media. Project for a lithograph 1988 — not used. However, see *The Divine Dream*, 2003. PG25 and work in progress *Ma Grande Baigneuse*, 2018-2019, oil on board.

Three pages of the working drawings for prints — (top to bottom) *Famille Lissac* (2003. PG18), *Making Heaven Happen* (2003. PG20) and *Tent of Eternal Love* (2003. PG21) — showing the creative process.

The Prints

(Selected and with captions by Anthony Green)

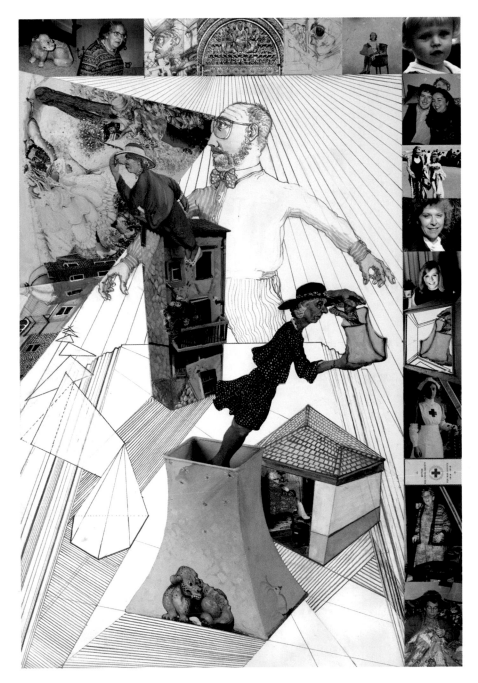

Making Heaven Happen, 2003. PG20

'…and sometimes you fail' Anthony Green, 2018.

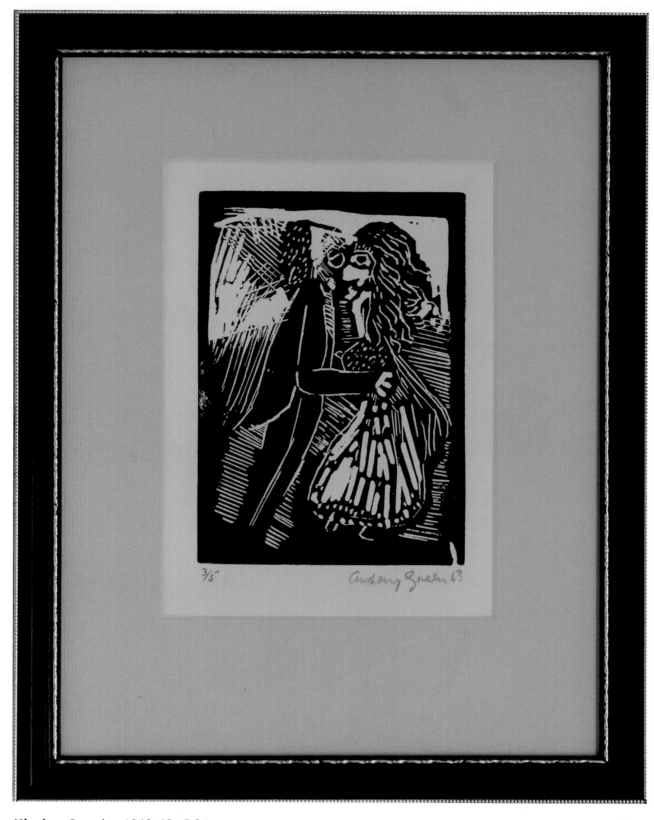

Kissing Couple, 1962-63. PG1

During quiet moments while teaching still life drawing in the art department at Highgate School, I cut and painted ***Kissing Couple*** and ***The Ravisher***. European Expressionists strongly influenced my picture making (***Gospel Oak: Self-portrait***). Only hopeless cricketers were permitted by their Housemasters to 'do art' on Wednesday afternoons.

The Ravisher, 1962-63

Gospel Oak: Self-portrait, 1963.
AG24

Three photographs showing our bed-room in The Ritz Hotel, London.

Hollywood male leads frequently embraced their heroines with a hat on. In 1988, Curwen Press invited me to make lithographs in their basement print studio off Tottenham Court Road. Helped and advised by Master Printer Stanley Jones, I drew on zinc plates for *Kiss At The Ritz*, 1988. PG2 (top of the page opposite).

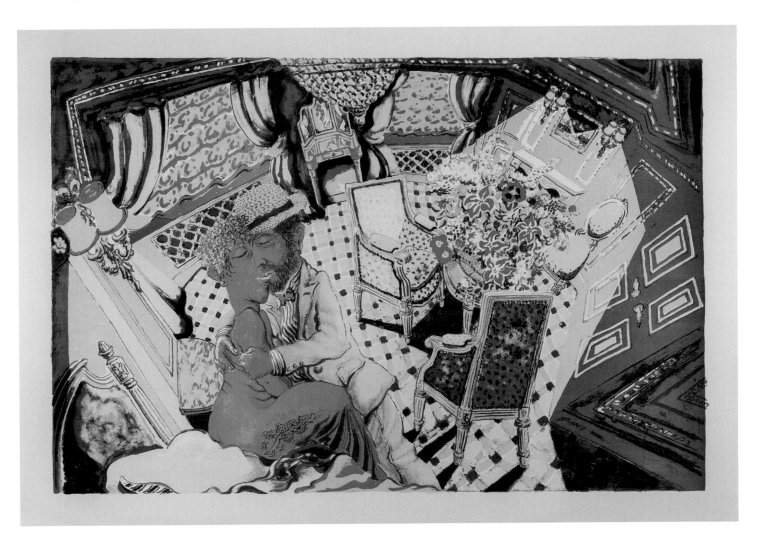

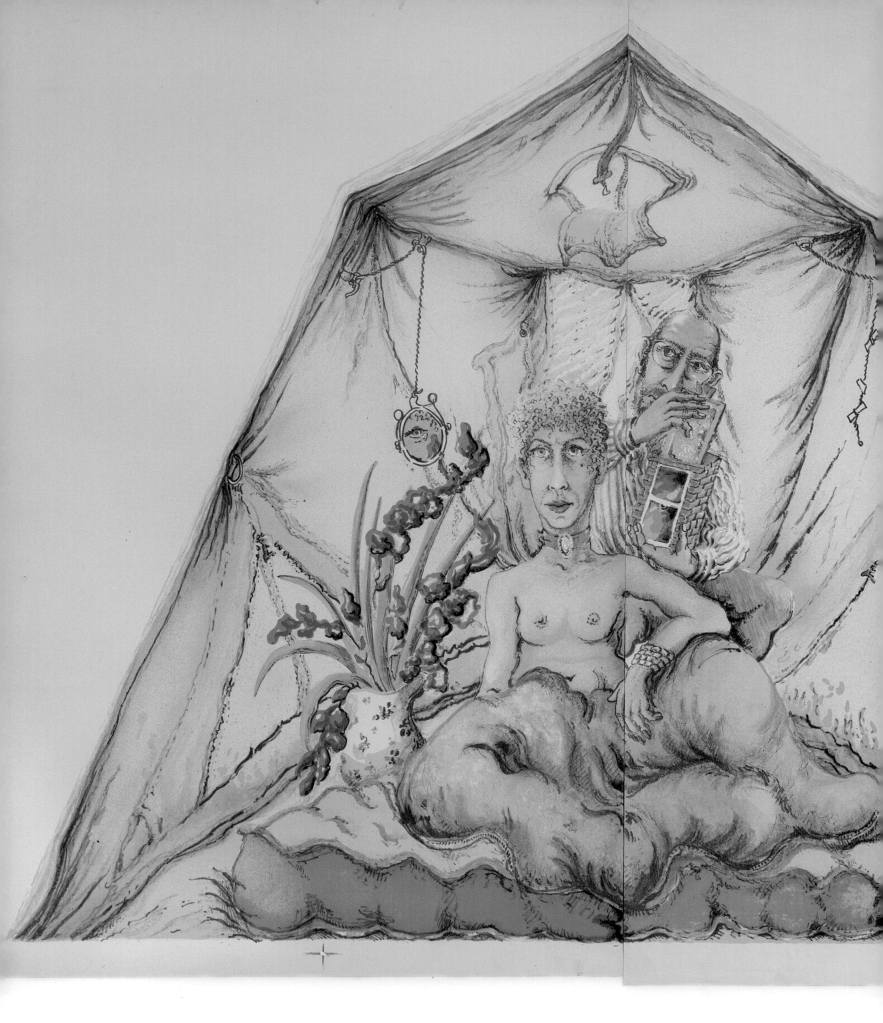

Mary Cozens-Walker's Box
And Anthony Green's Tent,
1985. PG4

The Bathroom by Mary
Cozens-Walker, 1988

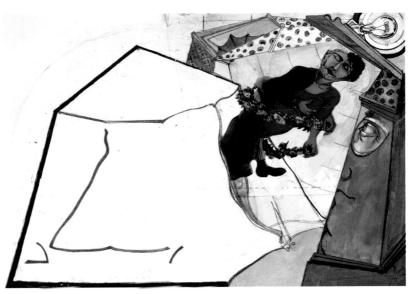

Tent Of Eternal Love,
2003. PG21

Tent purchased in New Jersey
for our camping journey en
route to live in California 1968.
Tent crated and airfreighted
to London in 1969 as wrapping
for new paintings. Tent pitched
on Farmer Rusbridge's land at
Earnley, West Sussex in 1970s
for summer holidays. Usually
campers do not travel with jugs
of gladioli and an embroidery
frame – but lovers do...

The Garden: Anthony And Rosie,
1988. PG3

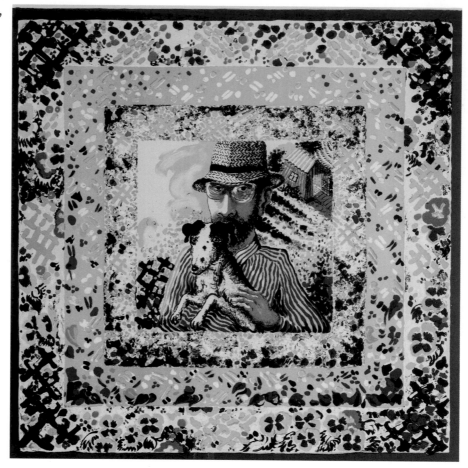

Sketchbook working drawing for *Passion IX*

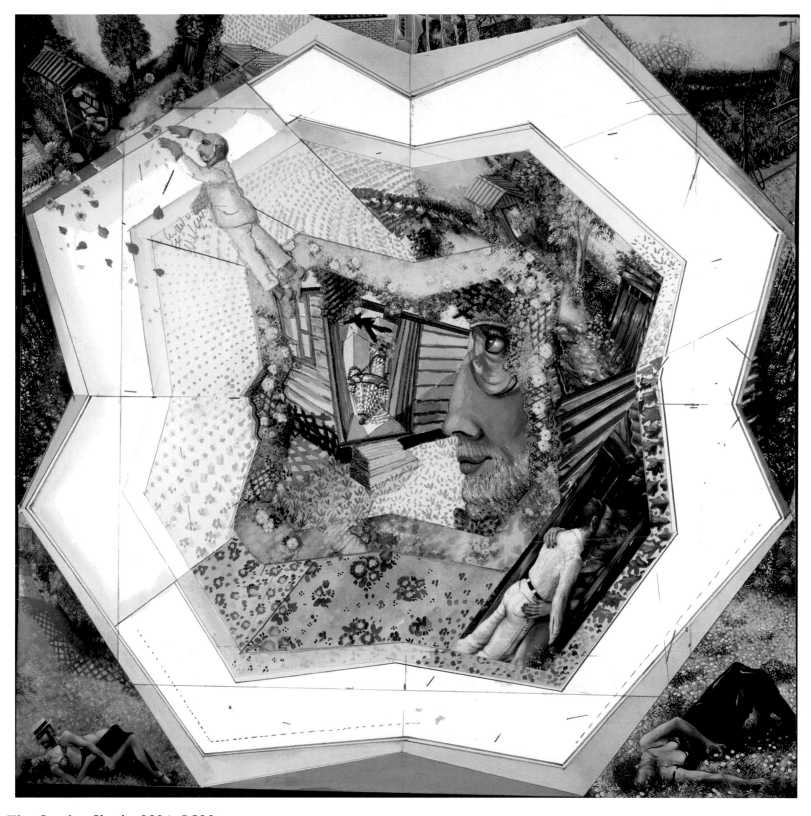

The Garden Sheds, 2004. PG28

In 1972, we bought an old cottage and garden with two sheds at Little Eversden in Cambridgeshire. In 1988, Curwen published *The Garden: Anthony and Rosie*. My sketchbook pencil drawing includes trellis, golden sunflowers, our fox terrier and her master's panama. By 2005, we had finally settled down adding five more sheds. So *The Garden Sheds* is just a progress report.

Flowers On Margaret's Trestle Table, 1998. PG5

From the drawing of *The Garden* (1988), influenced by 12th Century Japanese art, I selected a large section to be redrawn by me and published by Curwen Studio as a black and white lithograph, *Flowers on Margaret's Trestle Table*. The print could also be hand coloured by the artist. Originally print sellers advertised 'Penny plain, twopence coloured'. The flower vase was first used in a Royal Academy poster in 1973 – a useful prop which has regularly appeared in my pictures ever since, including *The Lissenden Mansions Kitchen Table*.

The Lissenden Mansions Kitchen Table,
2003. AG450

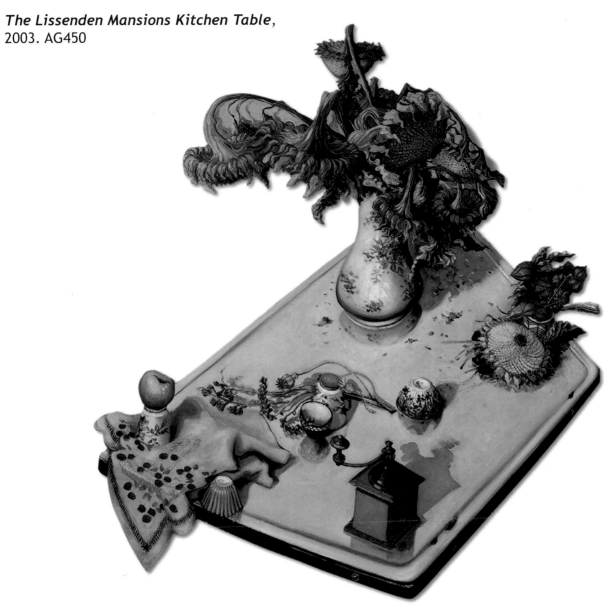

The Garden,
1988. Pencil on paper

Working drawing for
Lovely, 1995

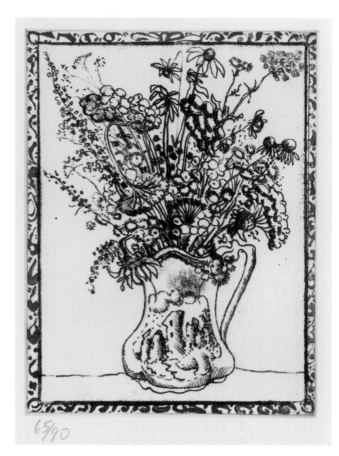

*Vase Of
Flowers*,
1995. PG8

65/90

Lovely,
1995. PG6

27/30 "Lovely" Anthony Green 95

Splendour,
1995. PG7

'95- 'Splendour' Anthony Green

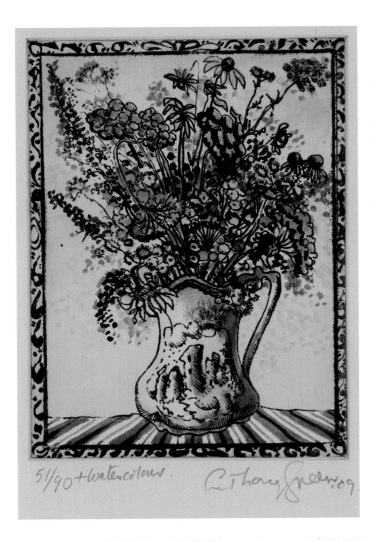

51/90 + Watercolour. Anthony Green '09

Vase Of Flowers, 1995. PG9

During the 1990s Norman Ackroyd encouraged me to make soft-ground etchings, posting me the prepared tissue covered copper plates. I drew my pictures and returned them for proofing. Afterwards the postman delivered my first black and white etching, *Vase of Flowers* (1995).

Later in 1995, again under Norman's supervision, I made two further etchings in the print studio at the Royal Academy Schools: *Lovely* and *Splendour*.

Norman Ackroyd 1 Morocco Street London SE1 3HB 071-378-6001

15-12-94.

Dear Anthony,

You realise, of course, that we are breaking new ground 'etching by post'

The flowers have etched perfectly

The 'Domestic scene' had a slightly heavier ground especially in the bottom right hand corner but was etching so beautifully around the top left and down the left hand side I have left you the option to add to it with a second drawing which will add depth to the finished plate which will surprise you.

61

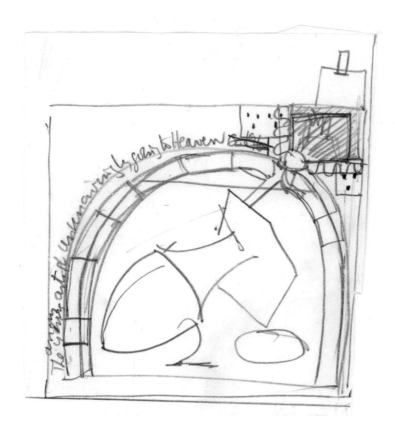

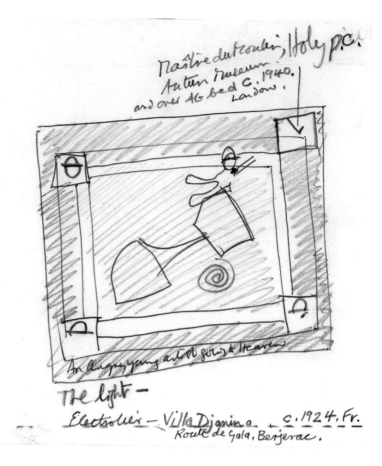

Two working drawings for **The Electrolier**, c1999

The chandelier was purchased in 1923 to hang in my grandfather's newly built villa in Bergerac. Until 1939, he used the house for family summer holidays. By 1943, the Germans had crossed the demarcation line into Vichy France. Their officers occupied the villa. Casimir Dupont had lived and worked in London since 1900 (see **Homard Newburg – Chef de Cuisine**, 2006) but the locals lied saying that the owner was in Paris on business. The Germans made a hurried exit in 1944 having drunk all the claret. But they did not touch the villa and the chandelier survived. Grandson Anthony was the only relative with a ceiling high enough to use it – my 'light of the world'.

Resurrection: An Act Of Faith, 1996-1999. AG416

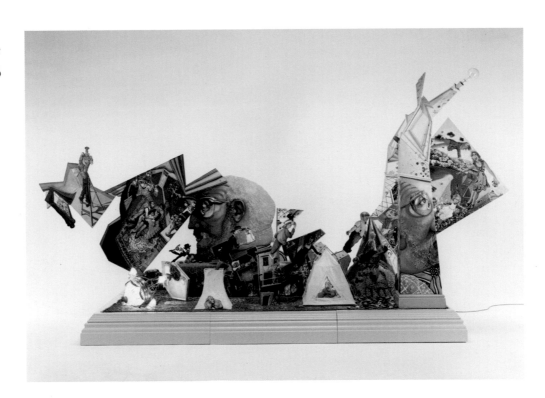

The Young Artist Unknowingly Going To Heaven, 2000. PG11

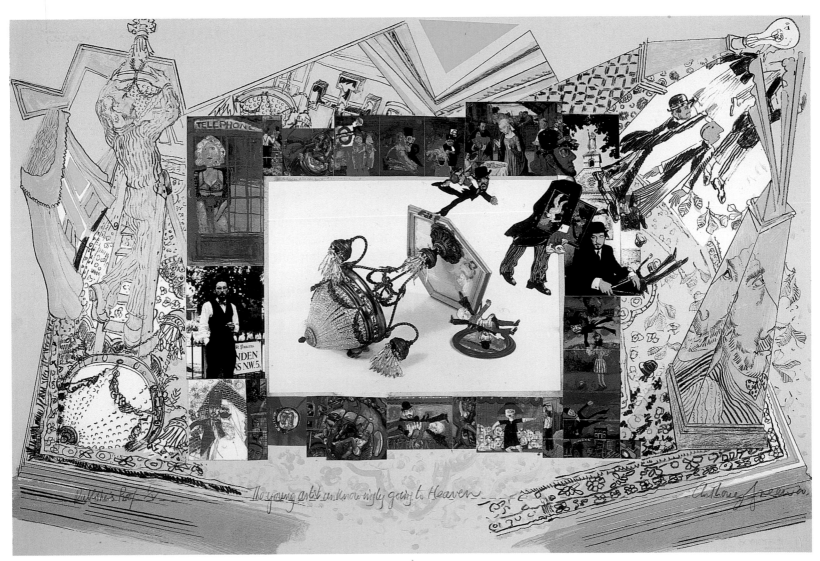

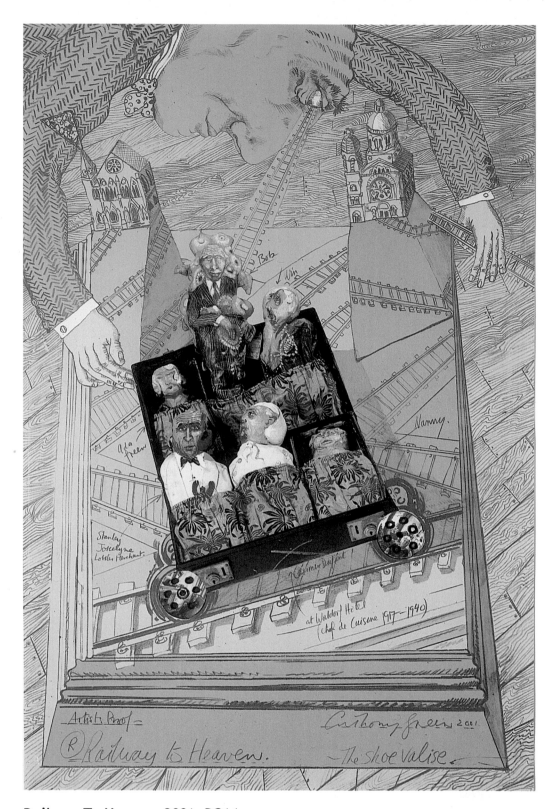

Railway To Heaven, 2001. PG14

My father-in-law died in 1984. Eighteen years later, the King's College Cambridge portfolio was published. It included my screenprint ***Bob Going To Heaven Quickly***. ***Railway To Heaven*** shows Anthony Green arranging a shoe valise of dead relatives going by train to Paradise.

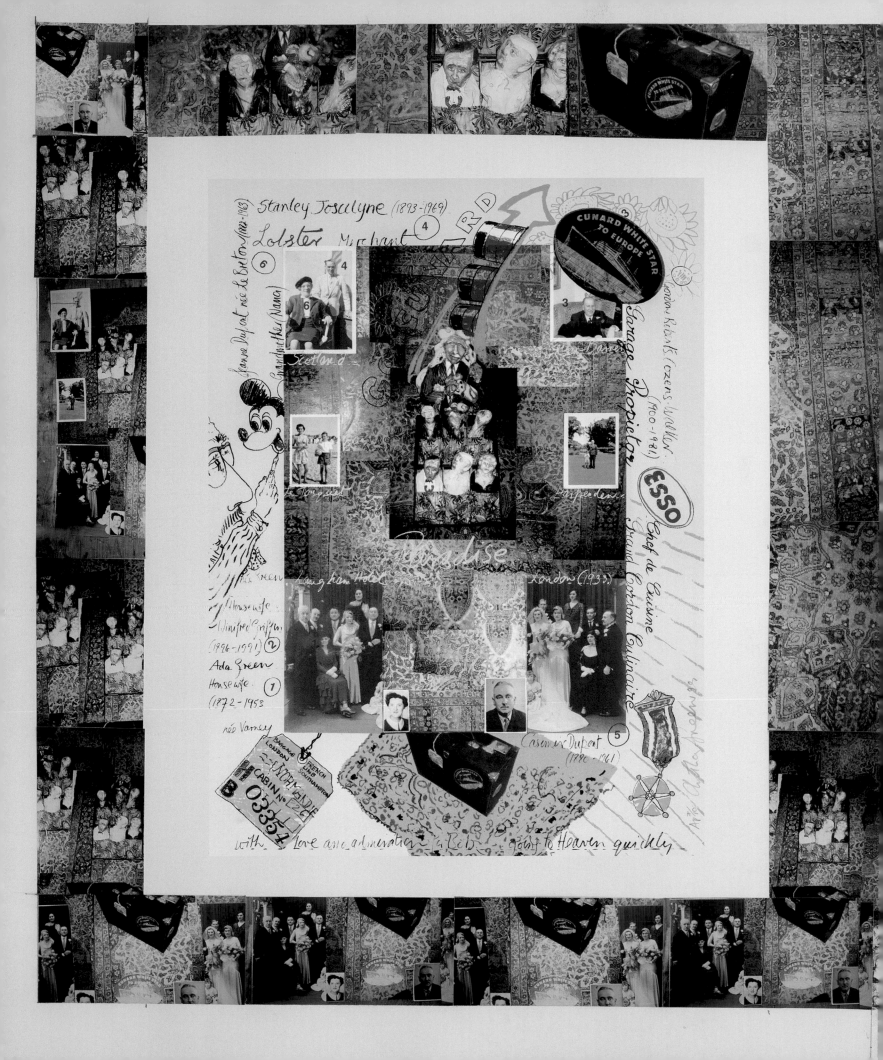

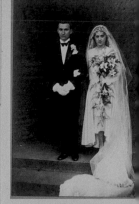

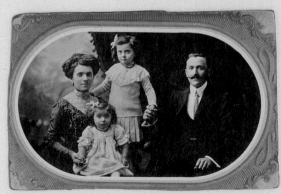

Famille Dupont - London - 1912.

Family Dupont
collage, 1907-1997
(left)

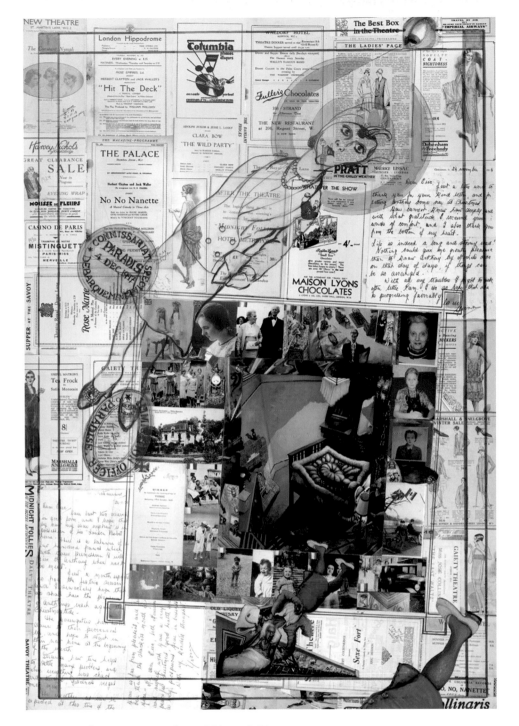

Yvonne Lissac: Une Vie, 2003. PG15

My French aunt, Yvonne Lissac, was born in Euston Road. Convent educated, she spoke fluent English and adored the London theatre and cinema. In 1928, she married Maurice Lissac, moving to Paris where their son was born. Maurice was drafted into the French army in 1939. Yvonne and her son, Michel, 'temporarily' returned to stay with their Dupont family in London. With the Fall of France, Maurice did not see his wife and son until the Liberation in 1944. The unhappy marriage lasted 60 years.

craft Industry.

Regal Rubber Co - 345 Edgware Road. London.

1933.— —1939.—

Tyre Merchant.

12 South Molton Street
W.1.
Green

The person whose signature appears
above is employed by the Aeronautical
Inspection Department

W. Bagnall-Owen
Chief Inspector,
Aeronautical Inspection Dept

This pass expires twelve month
after date.

23. JAN. 1917 Date.

Aircraft Industry 19

f F. S. Green

Regal Rubber Co:

"Paddy" Tyre Fitter
F. S. Green trading
from 75 Lanark Rd.

ol Report 1907 →

Green = Engineering Student

LONDON COUNTY COUNCIL

Mr Brooke is greatly satisfied with
progress made by Fred Green this term.
We consider him a very promising
pupil. He is very promoted to Stan 3

Report to Parents of
Scholar's Attendance, Conduct and Progress,

FOR THE TERM ENDED July. 1907

Name. Fredk Green Standard 20 3rd
No. of Scholars in Class 40 Place in Class

Number of Times the School was open
Times absent Times late

Subject		Subject		Additional Subjects :	
Scripture	Ex	English	Ex		
Reading	Ex	History	Ex	Composition	Ex
Writing	Ex	Geography	Ex		
Arithmetic	G	Needlework			
Spelling	Ex	Home Work			
Drawing	VG	Conduct	G		

NOTE:—
Ex.=Excellent;
V.G.=Very Good;
G.=Good;
V.F.=Very Fair;
F.=Fair.

T. C. Brooke Head Teacher.
Class Teacher.

Carl Branz, Glen Orthy, F. S. Green, W. Chapman.
Goodyear Tire and Rubber Co - Ohio. C. 1927.—

A.I.D. Staff at Kroll and Co. Sept 1917.

Family Green
collage, 1899-1961
(left)

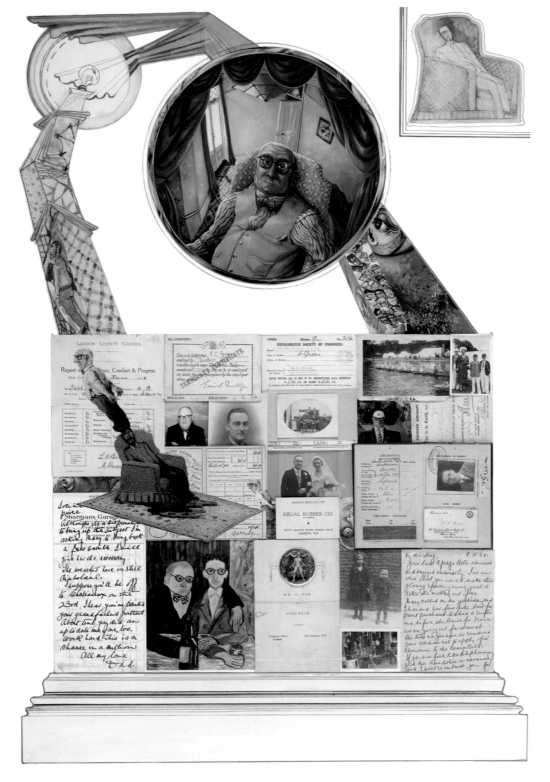

An Enigma – The Artist's Father, 2003. PG17

Dad remains an enigma. Why, over fifty years later, after he had gargled down gallons of Johnnie Walker and broken my mother's heart, do I still miss his wit, intellect and sense of humour? He lived long enough to know I was on a French Government Scholarship to France. There, lurking in the borrowed 'ping-pong' room and shortly to return to London to marry Mary Cozens-Walker, I resolved to chronicle our great love.

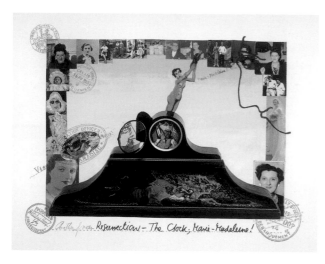

The Clock: Marie Madeleine (Version I), 2000. PG13. My mother married F S Green in 1933; divorced 1954. Married S Joscelyne in 1954 and he died in 1969.

The Clock: Marie Madeleine (Version II), 2003. PG16. Mum escaped from the clock into the tender yet passionate arms of a new husband. My father never recovered from the shock. His pride, lubricated by alcohol, led straight to his death aged 61.

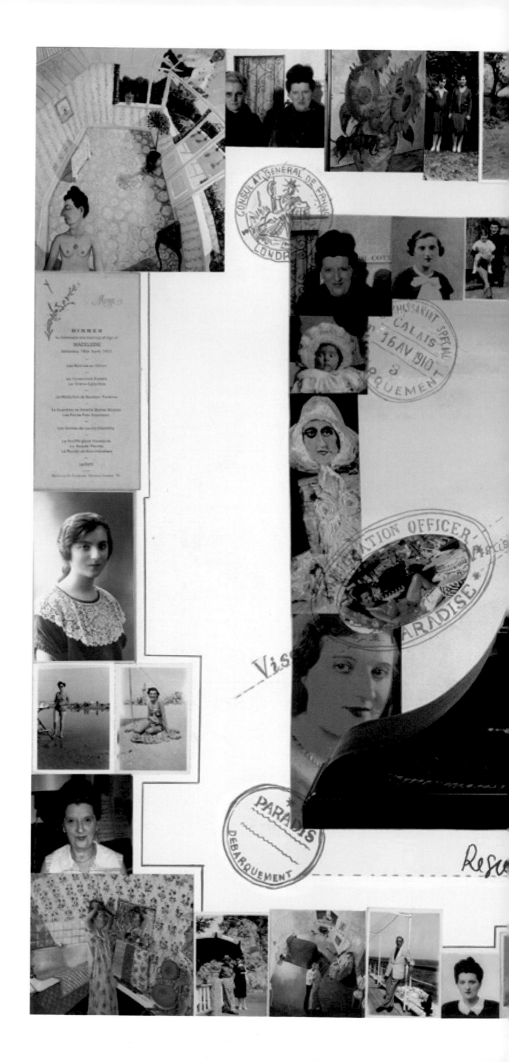

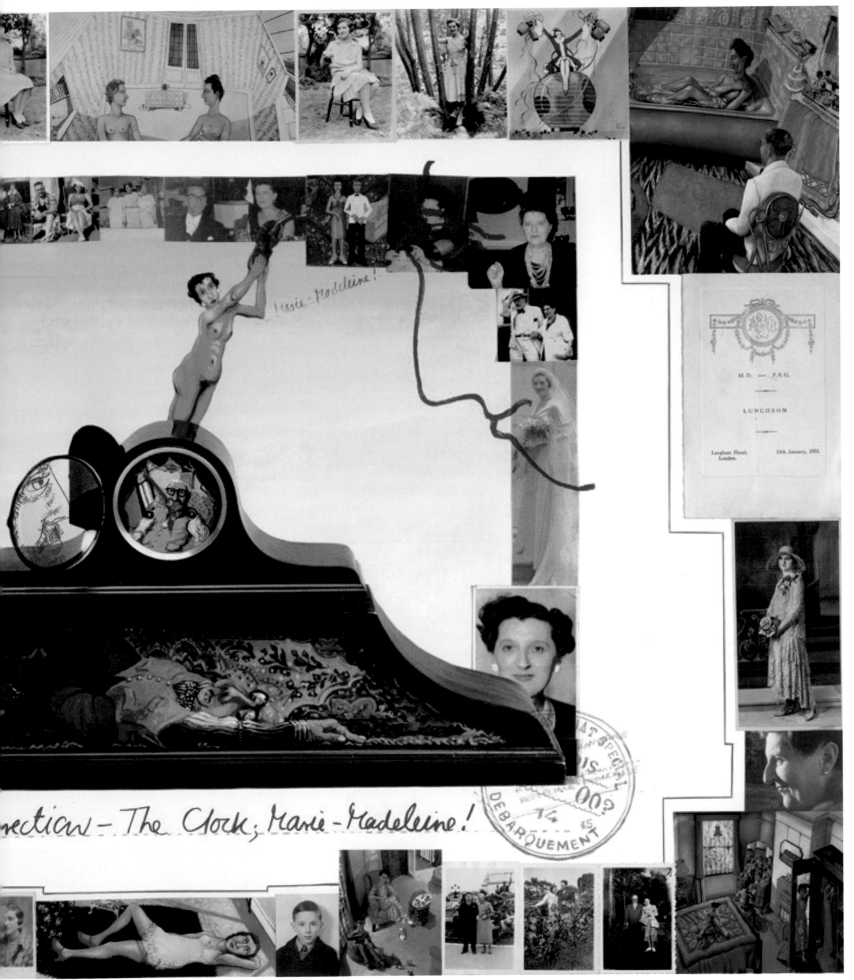

rection — The Clock; Marie-Madeleine!

Marie-Madeleine!

Mademoiselle Nunez.
Paris 1954. _

" 1954.
" Ma _
petite _
Parisiène "

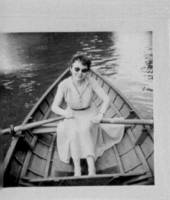

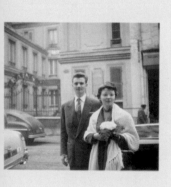

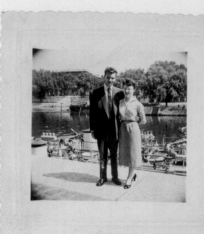

"En plein travail" _ _
Le Bois de Boulogne : juin 54.

_ Juin 1954.
Les quais de la.
Seine près du _
'Vert Galant'

Isabelle et Michel _
Notre mariage - Paris
20 Decembre 54.

Davis Michel Lissac
on leave from Navy
with Isabelle and Yvonne

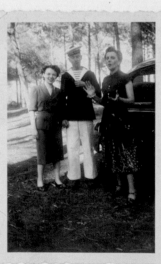

Marc Lissac.
(1964 - _)'

Christine _.
(1959 - _)

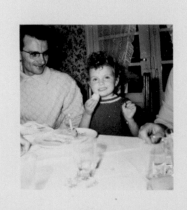

Famille Lissac
collage 1899-1961
(left)

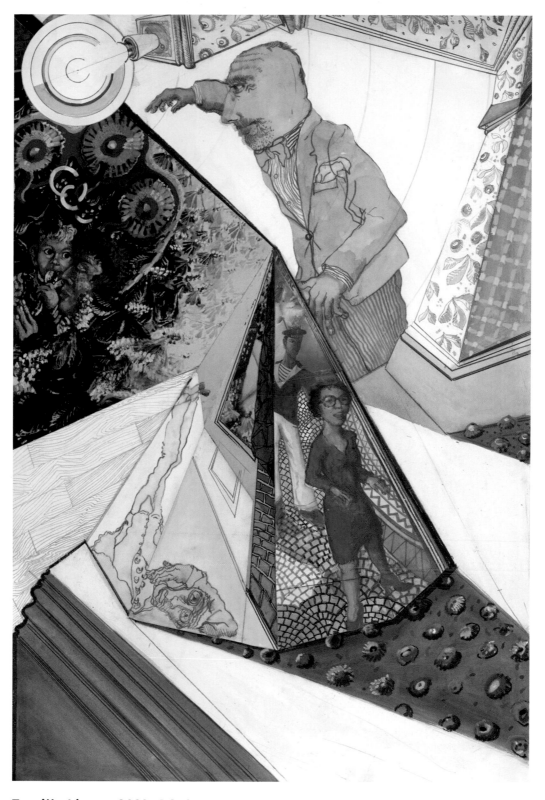

Famille Lissac, 2003. PG18

Anthony Green,
c1954

Maurice Lissac vehemently opposed his son's marriage to Isabelle Numez. They married in Paris on 20 December 1954. It has been a long, loving relationship. Cravenly, no close family attended the wedding except his young schoolboy cousin, Anthony Green. Their son Marc is pictured with Alexandre, their grandson. Maurice Lissac outlived my aunt. He died unloved and alone.

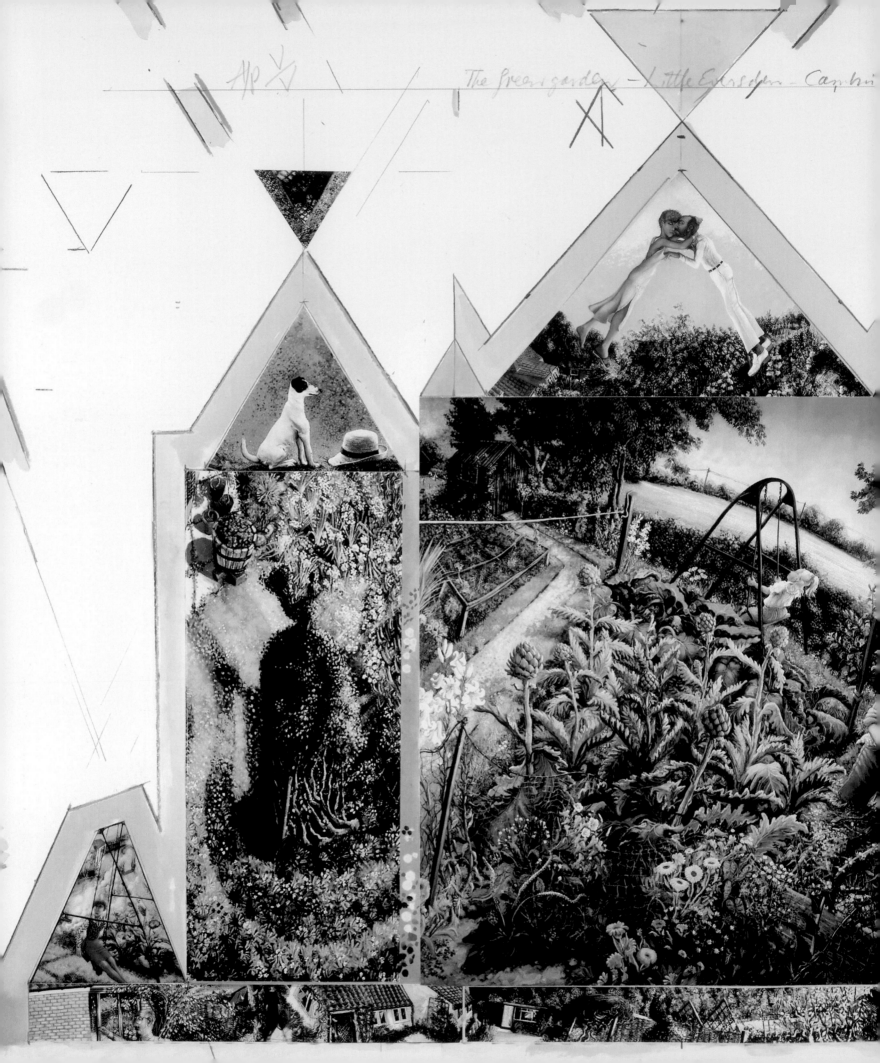

The Green Garden - Little Eversden - Cambri

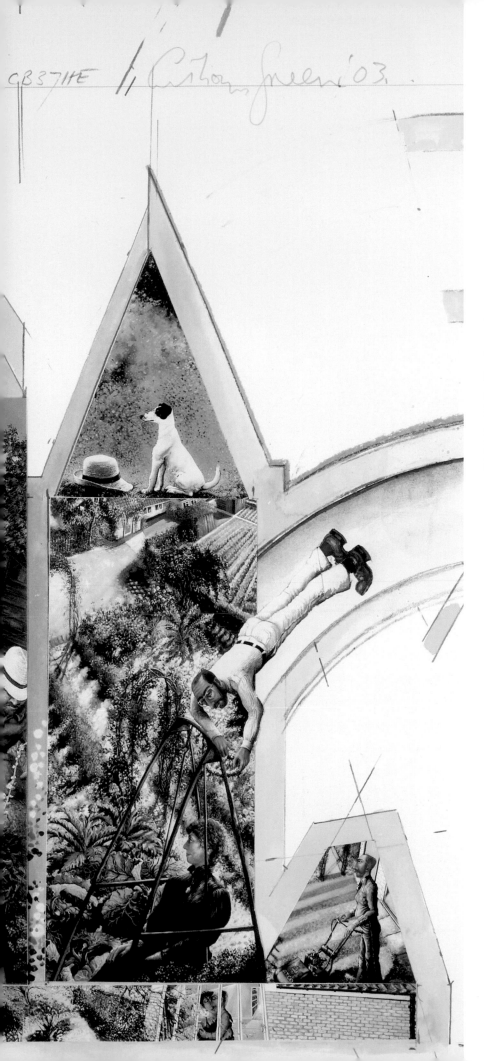

The Green Garden, 2003. PG23

Take segments of eight Green oil paintings. Cut, scissor and collage a new composition. Love peeking down a cleavage, a fox terrier, a topiary peacock bush, Lucy swinging, the gardener composting, crowning Mary with daisies and, right along the bottom edge, 'going to the studio for a kiss'. The business of the garden.

The Enchanted Garden,
Twentieth Wedding Anniversary,1981. AG273

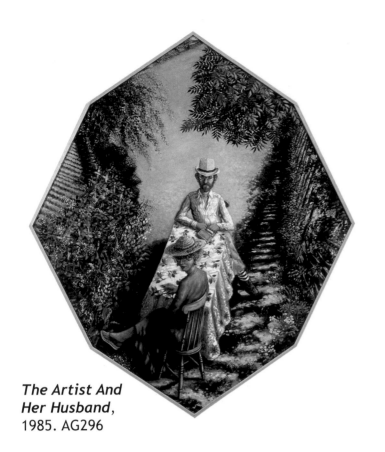

**The Artist And
Her Husband**,
1985. AG296

**Young Lady
With A Fox
Terrier In A
Decorative
Yellow Frame**,
1985. AG303

The Golden Garden, 2003. PG24 (opposite)
Working drawings and four garden paintings influenced
the final composition of this inkjet print. Pencil, gouache,
collage, watercolour and simple geometry celebrate a
family tea party.

Working
drawing for
AG303

Afternoon Tea,
1985. AG306

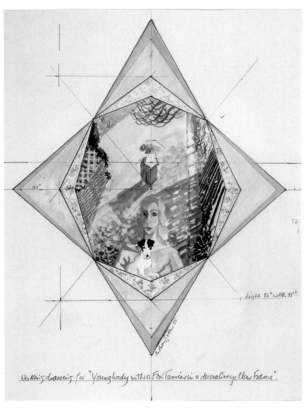

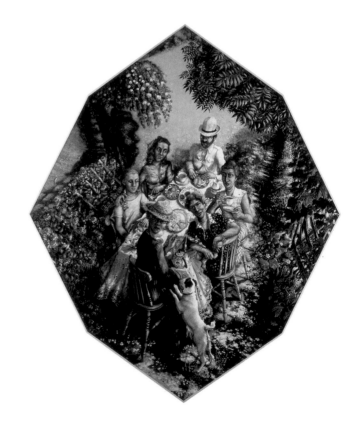

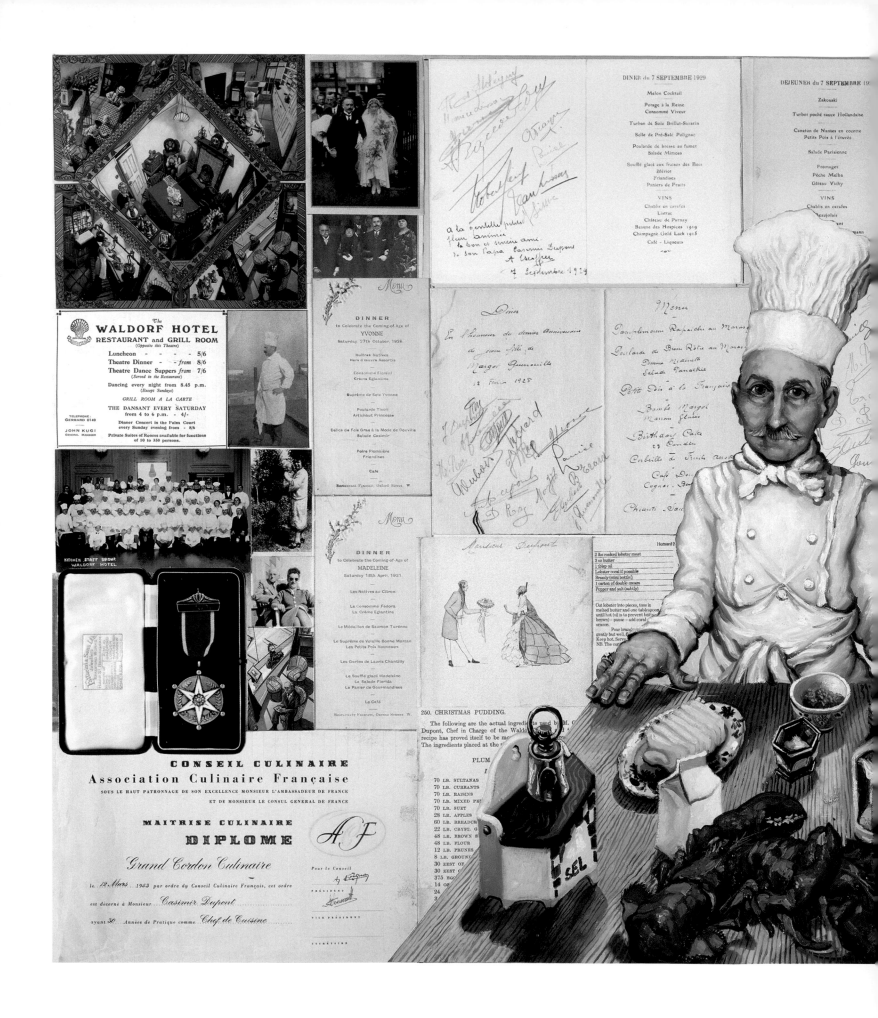

78

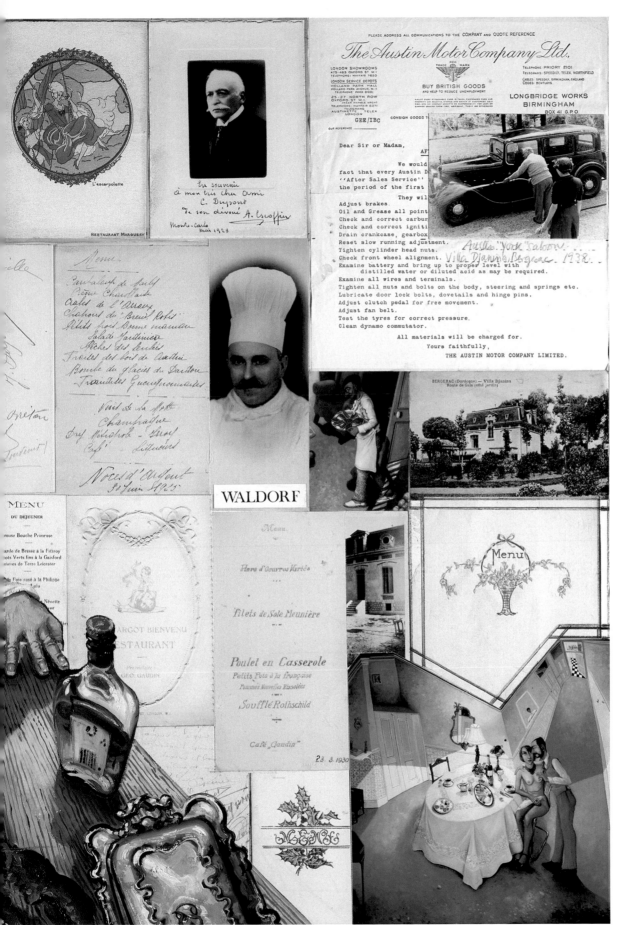

Homard Newburg, 2006. PG32

After the turn of the century, two economic migrants from France married in London. Casimir and Jeanne Dupont had two daughters, Yvonne and Madeleine. Yvonne married a French husband, Maurice Lissac and Madeleine an Englishman, Eric Green.

The Dupont family prospered, Casimir was one of Escoffier's sous chefs at the Carlton in London. In 1917, he became Chef de Cuisine at the Waldorf. By 1928, he had planned to retire back to France to his new villa in Bergerac. Alas, the Wall Street Crash wiped out all his investments. 1939 changed all his plans. He only retired in 1952 returning to France to live in Châteauroux with his eldest daughter and son-in-law. (See also ***The Young Artist Unknowingly Going To Heaven***, 2000)

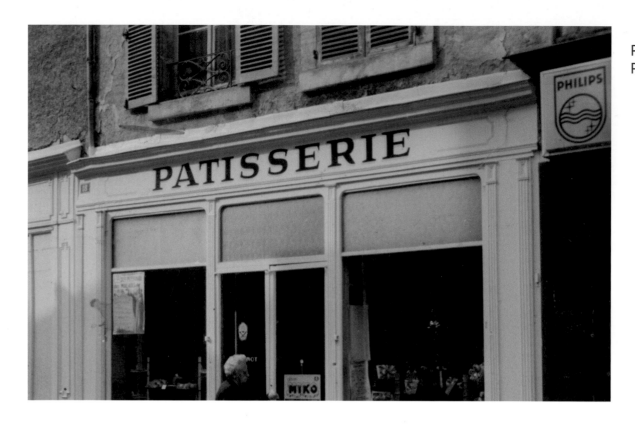

Photo of the Pâtisserie

Working drawing for
Venot, Argenton-sur-Creuse, Le Petit Gourmand, c1949-52,
2004

Pencil sketch for
J Venot, Rue d'Orjon, 2004

While staying with my aunt and uncle, who arranged for me to visit during all my school summer holidays, I discovered the cake shop in 1948. A fully clothed Madame Venot happily took my pocket money. On a sentimental return visit with my new bride in 1961, the coffee éclairs did not disappoint.

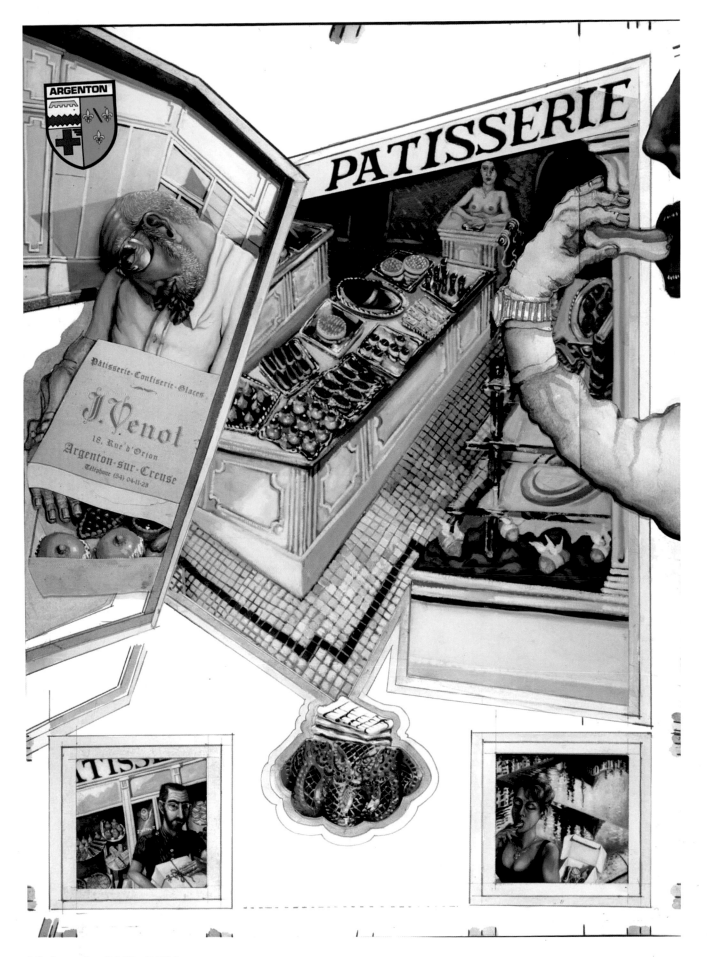

Pâtisserie, 2005. PG29

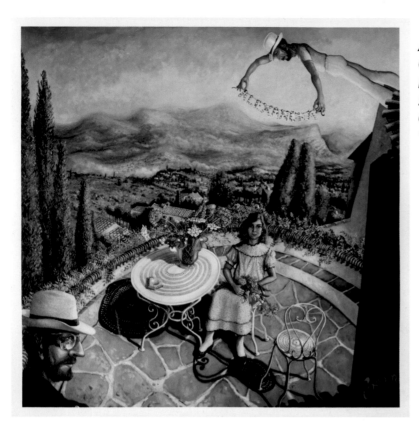

Alexandra: Carte Postale — Souvenir De Castelleras, 1977. AG231

In the summer of 1977, I went with Mary and the children to the South of France to paint Miss Alexandra May, seated on the terrace of a rented villa in Castelleras. Back in London, I painted three new oil paintings based on the 'rest and recuperation' enjoyed afterwards in Monte Carlo and Cannes. These gave rise in 2003 to *La Côte d'Azur -* sailors, sex and sun. A loving couple all lips and nipples.

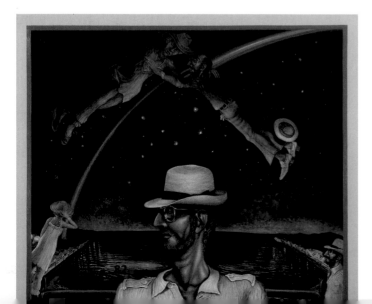

Cannes: Genuine Panama, 1978. AG235: One of the 'rest and recuperation paintings'

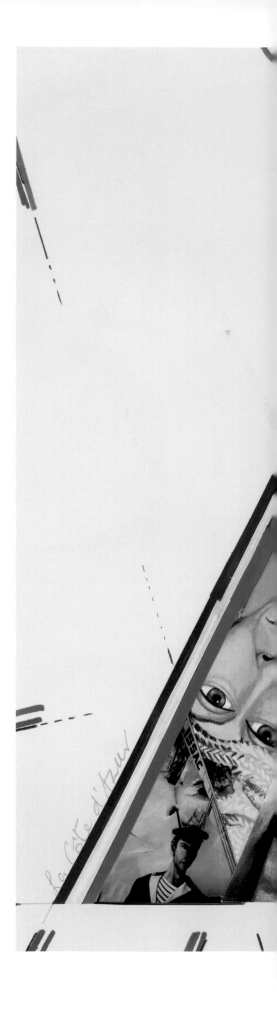

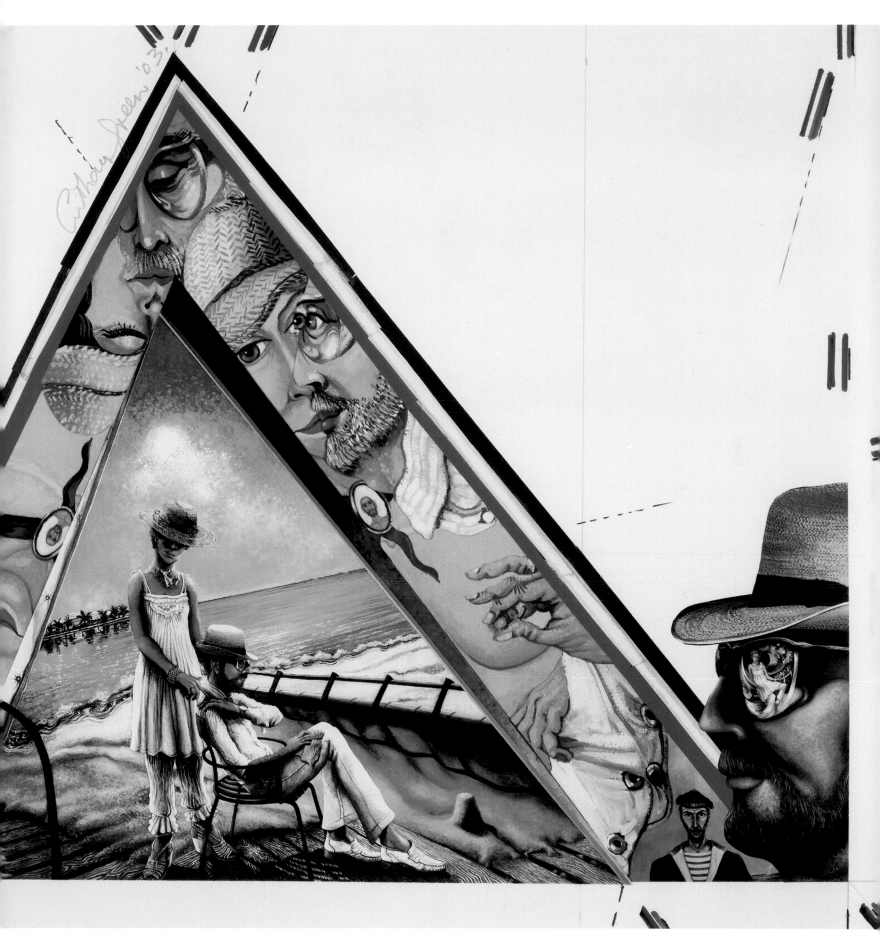

La Côte d'Azur, 2005. PG26

Tootsie, 2004. PG27

A glorious summer's day in fields close to home. Ordnance Survey map grid reference TL383544

Watercolour, oil, pastel and pencil on an inkjet print

The *Tootsie* print was the inspiration for a later working drawing for *Summer Landscape – Autumn Lovers*, 2003-09

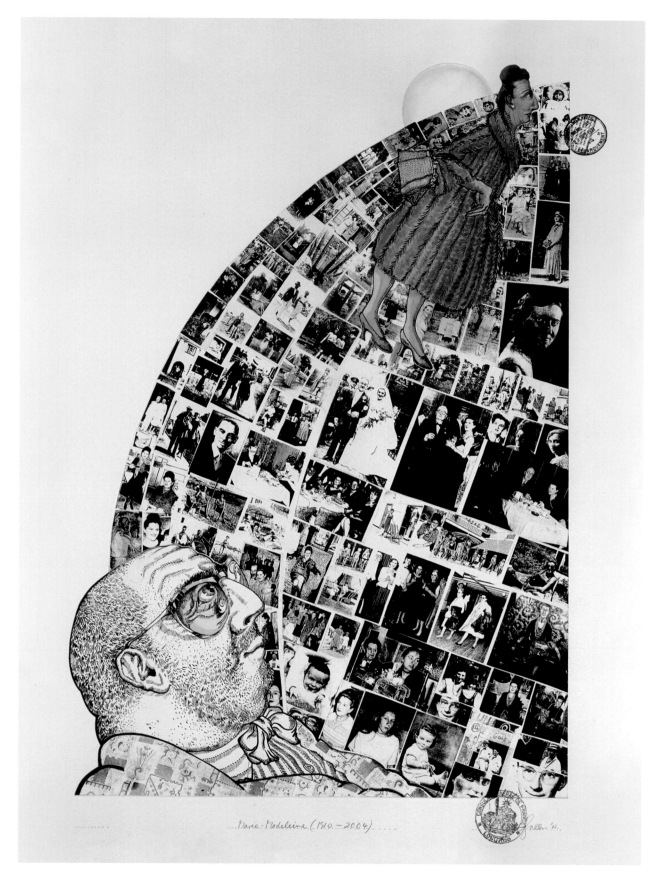

Marie Madeleine (1910-2004). Passport to heaven – a history in photographs. Infant, convent girl, flapper, white wedding, mother, man-made divorce laws, decree nisi, registry office, Stanley, P&O cruising, business woman, widow, more cruising with sister, lonely, dementia with an only son. A loving mother going to heaven in a mink coat.

Working drawing for
Marie Madeleine

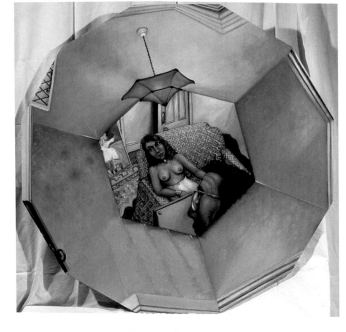

The Life Drawing (1961-62),
1985. AG299

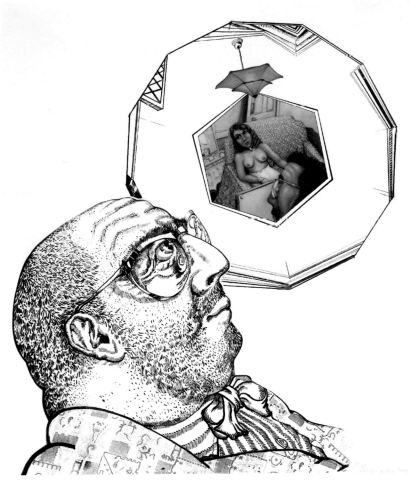

Autumn Love I – Pink Lounge, 2009. PG38
Same son adoring Mary Green

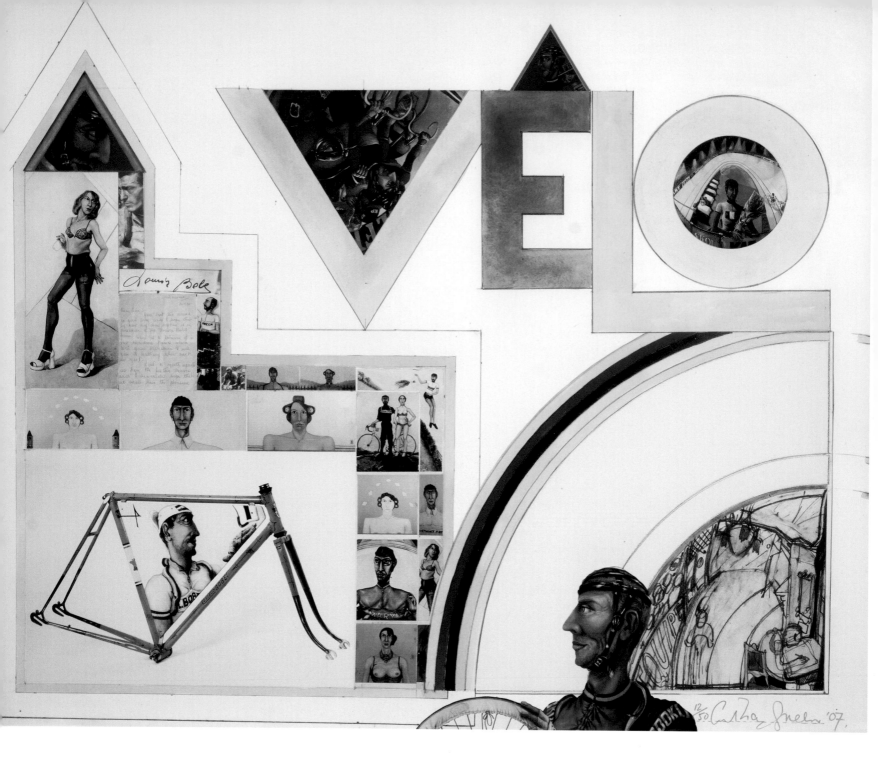

Vélo, 2007. PG34

Anthony Green – jeune pistard, champion derrière le gros motos, maillot jaune... Tour de France rider extraordinaire – in his dreams at least.

Maillot Jaune,1972. AG171

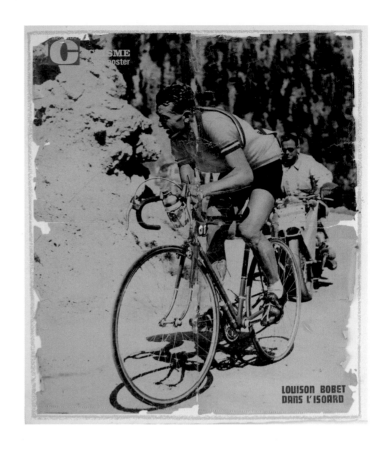

Louison Bobet

Champions, *1978-79.* (left
to right) AG246, AG245,
AG244, AG243, AG242

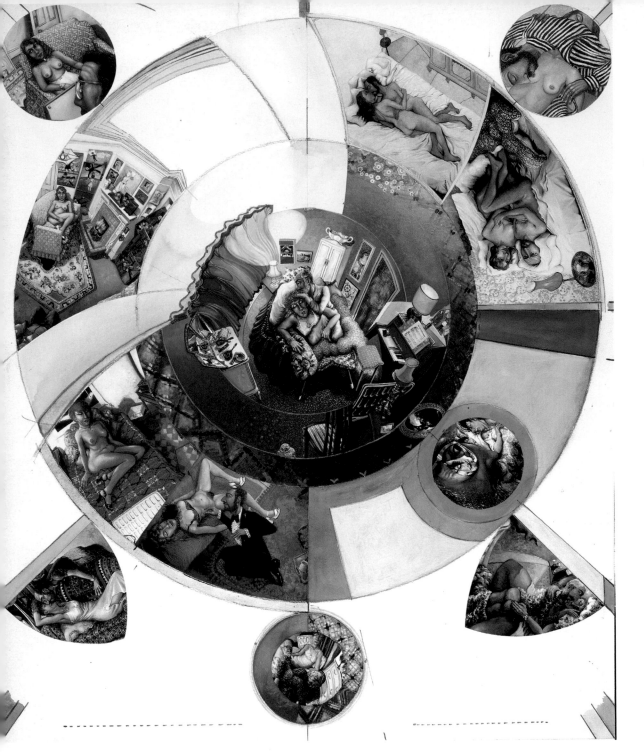

Detail from *A Ruby Wedding Anniversary* (right)

A joint venture, with Mary Cozens-Walker and Anthony Green each contributing 20 bits of their skill to make this lithographic patchwork.

Blue Pyjamas, 2007. PG35

Before alternators replaced distributors, the idea of spring-loaded counterweights expanding as engine speed increased certainly influenced this fast round composition.

A Ruby Wedding Anniversary, 2003. PG22

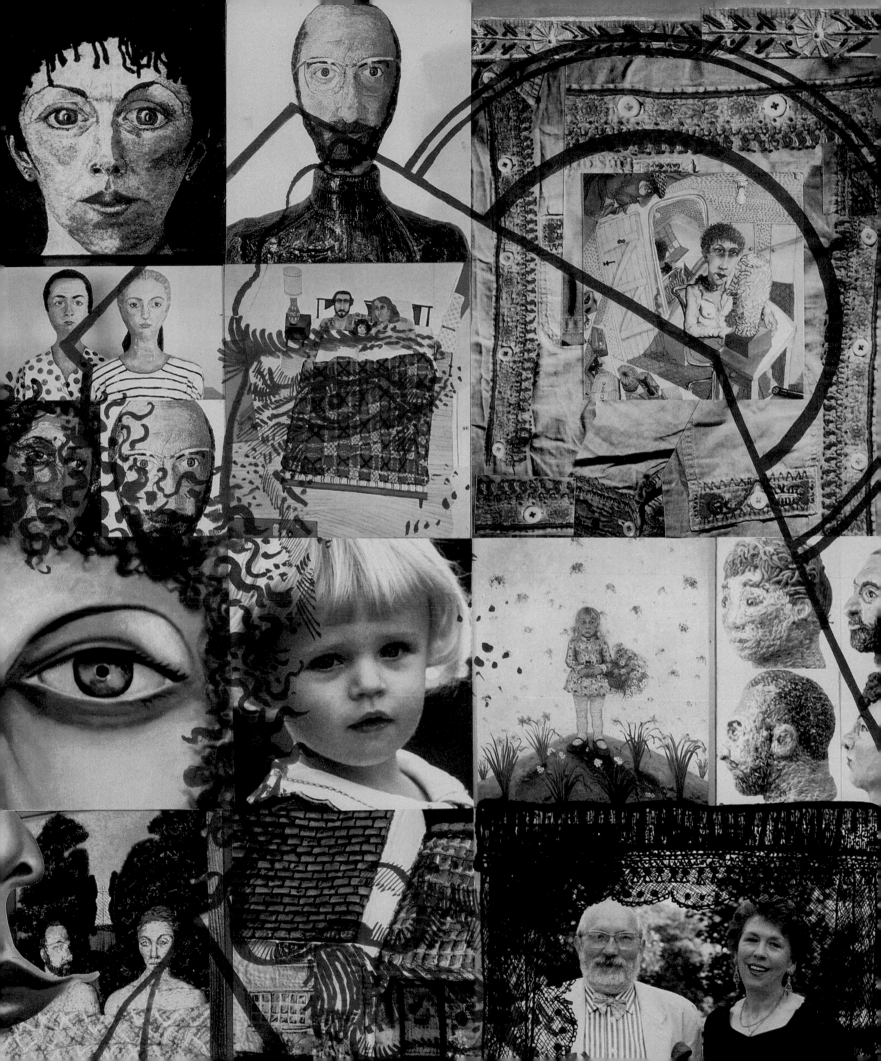

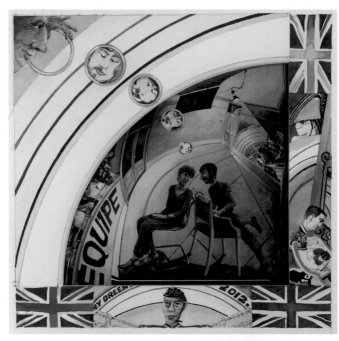

L'Equipe I, 2012. PG46

The London studio is turned into the six day cycle track at Empire Pool, Wembley. A trackman offers his girl a golden bangle.

Anthony Green with bicycle, 1955

Le Pistard: Trackman, 1976. AG220

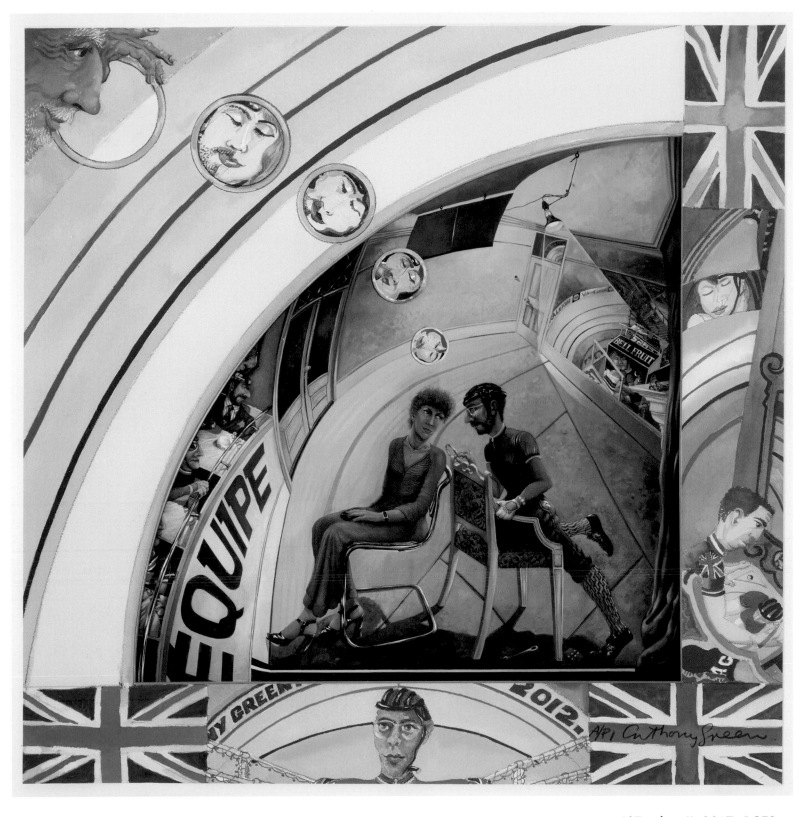

L'Equipe II, 2017. PG53

Trimmed and reworked with screenprint overlay
to suggest sentimental affection on the part of
an ageing artist for old cycling memorabilia.

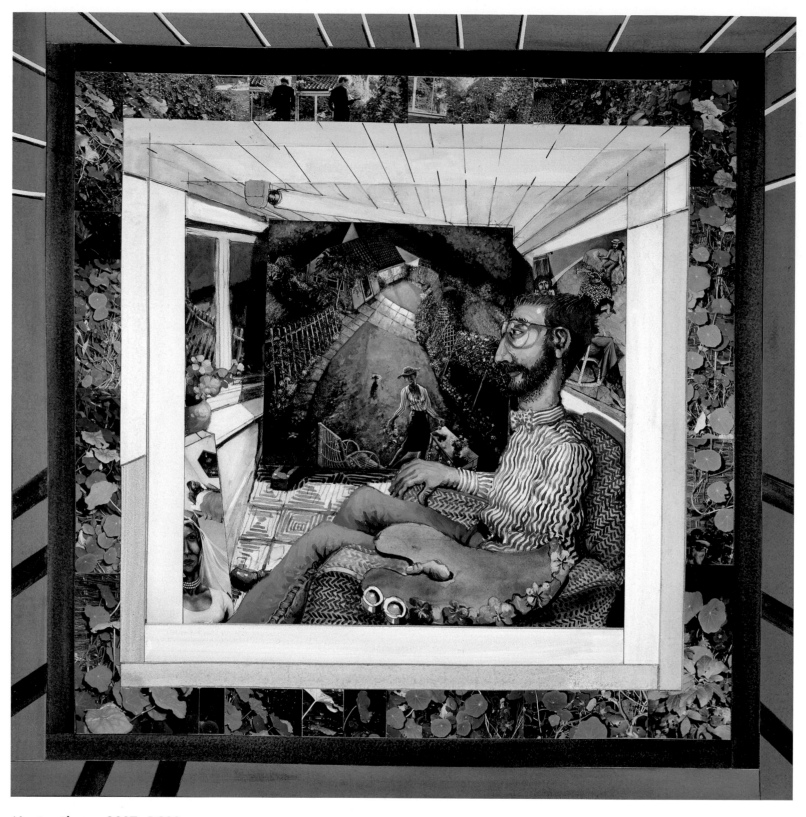

Nasturtiums, 2007. PG33

1976 was an excellent year for nasturtiums. *Nasturtiums* includes Mary by night (*Mary Arranging Nasturtiums at Mole End*, AG221), by day (*The Summerhouse, Little Eversden*, AG230) and at bedtime (*My Lovely Bride*, AG236).

Working drawing
for *Nasturtiums*

My Lovely Bride,
1978. AG236

Poster
showing
***The
Summer
House,
Little
Eversden***,
1977

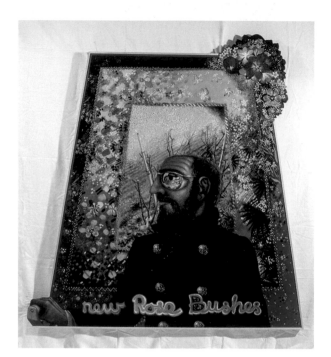

Passion VI: New Rose Bushes,
1983. AG285

Working drawing for
New Rose Bushes II

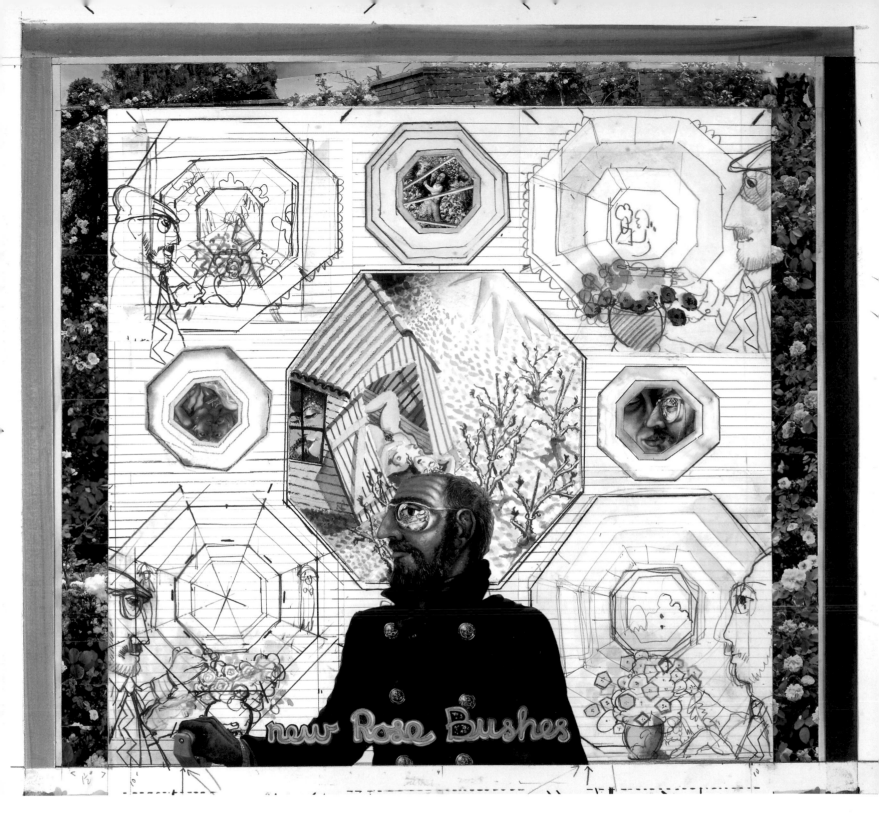

New Rose Bushes II, 2008. PG36

Life with the Greens. On Good Fridays, Mum and I popped into Notre Dame de France in Leicester Place. Then Dad took us to lunch at Kettners. The hors d'oeuvres trolley was irresistible. In 2008, it needed a mature artist's love of 'French cooking' to create *New Rose Bushes II* — the middle of paradise, two lots of passion, flower arranging and memories.

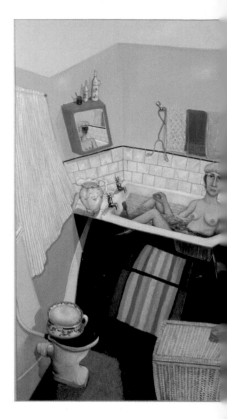

Our Bathroom, 1973. AG178

A generous benefactor presented silver medals to all Royal Academicians. We are encouraged to wear them at all the Royal Academy's events.

In 1973 I had painted my first bathroom picture, *Our Bathroom*. And in 2008 I produced an omnibus edition of bathtimes wearing the medal.

RA Diploma

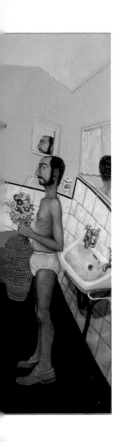

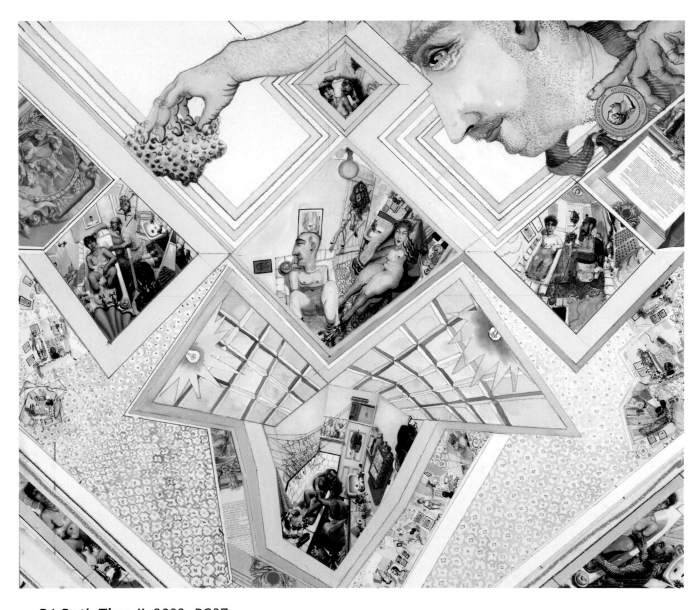

RA Bath Time II, 2008. PG37

Back view of Mary's hairdo

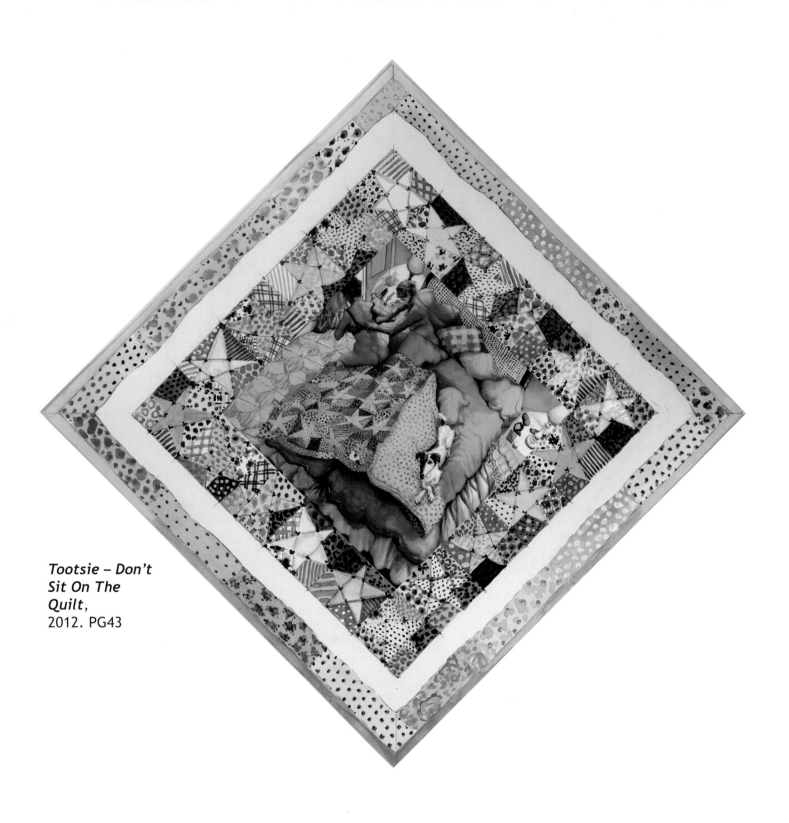

*Tootsie – Don't
Sit On The
Quilt*,
2012. PG43

Mr And Mrs Green And Their Fox Terriers, 2009. PG41

The Embroidery, 1993. AG347

The Path I, 2001. AG437

Rosie, 1993. AG348

Stiffkey – The Old Hall: Painting The Picture, 2012. PG44

In 2012, the owner of the Old Hall, Stiffkey was undertaking its huge and inspired restoration. He invited me to make a small edition print of 'Anthony Green recording his huge project'. In 2007, I had painted and installed a shaped oil painting of the Hall, garden and surrounding stream and landscape (The Bell Commission: ***The Old Hall, Stiffkey***, AG474).

Autumn Love II – The Swing, 2009. PG39

Swings swing. In 1976 Mary sat on the swing and the bottom edge of the painting was reassuringly horizontal (*Autumn Swing,* 1976. AG224). Many years later in the print, *Autumn Love II*, the swing, the painting, the field, the sunflowers and the profile are moving...

In 1980, the rectangular shape of *Passion I* (1980. AG263) was made 'in perspective' to accentuate the vanishing yellow clothes line. The print, *Autumn Love III – Red Hot*, initially appears as a familiar and reassuring rectangle. It is not — it is drawn purposely 'wrong'. Looking and seeing require great care.

Working drawing for
Autumn Love III –
Red Hot

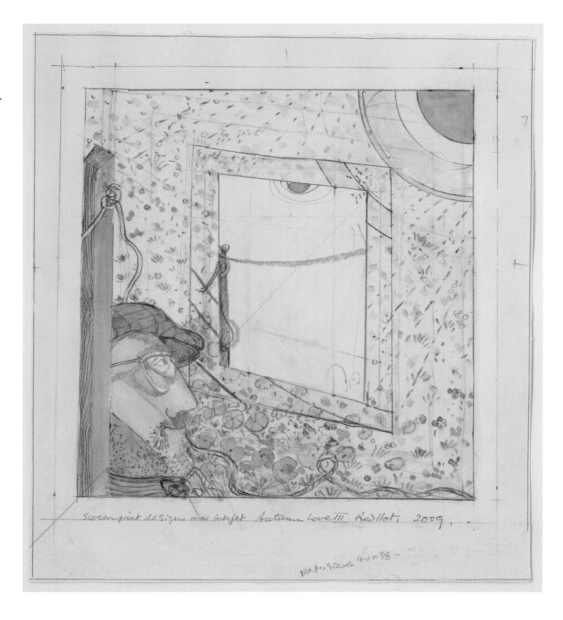

Screenprint design over inkjet Autumn Love III Red Hot, 2009.

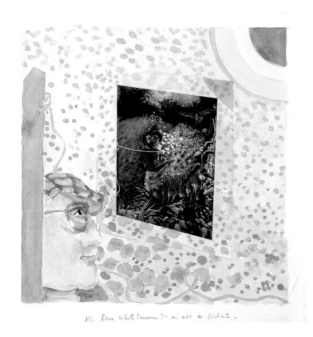

Autumn Love III –
Red Hot, 2009. PG40

Anthony Green on
the swing

Girl In His Pocket,
2012. PG47

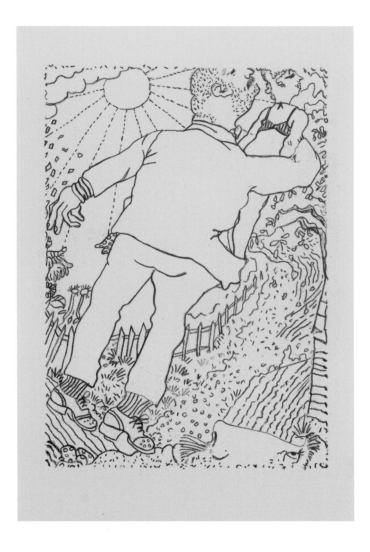

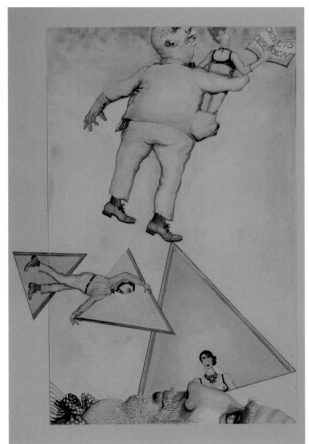

Girl In His Pocket
Watercolour

A large watercolour to celebrate our Golden Wedding influenced the subject matter of *Girl in His Pocket*, 2012. PG47. A small screen print – and occasionally I might hand colour bits of it.

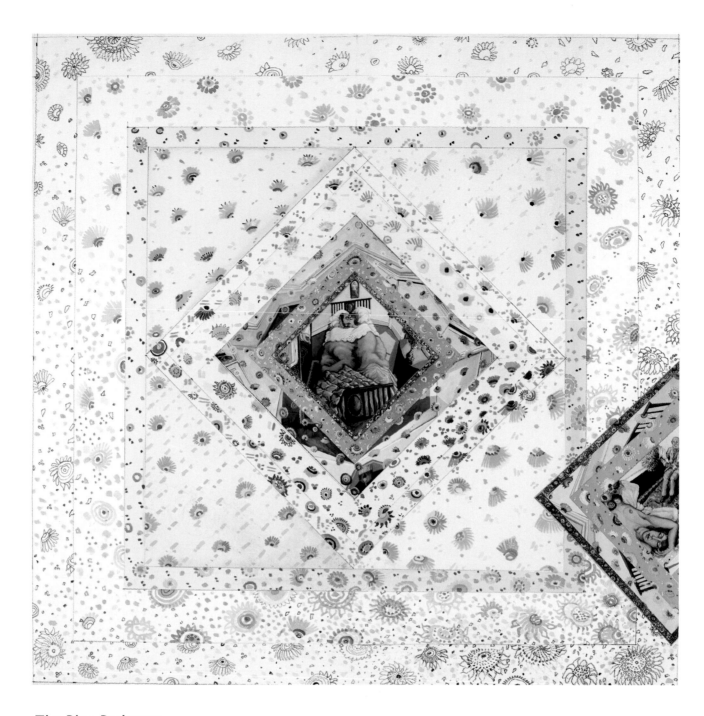

The Blue Bedroom,
2013. PG45

Memories of our first
bedroom at Lissenden
Mansions NW5, c1966. In
2013, the elderly suitor's
bouquet is wilting.

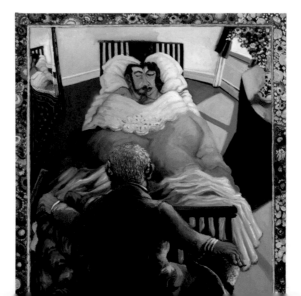

Modern Olympia VIII,
2012. AG529

An increasingly deaf artist
fondly remembering north
London.

107

*The Garden
At Little
Eversden —
Monkey Puzzle
And A Tub Of
Hydrangeas I,*
2016. PG49

AP 6/6 Anthony Green 2016.

Garden photos

The handwritten annotations on the drawing include:

Sun yellow + pink edge

Burnt sienna + yellow

trunk of monkey puzzle yellow with lower thin line of burnt umber.

chestnut leaves. Burnt sienna + yellow + dark accent umber.

yellow eye circle

nose white

hydrangeas pink + dot of burnt umber.

lip pink

lip/pink

hydrangeas in tub — no colour ?

2016

left eye — white highlight

— pink/cadmium
- pale cadmium yellow
- Burnt Sienna + yellow tones
- Burnt umber for darker chestnut leaves

The Garden At Little Eversden —- Monkey Puzzle And A Tub Of Hydrangeas II, 2016. PG50

A colour etching commissioned by Kip Gresham. I hope that this work is the catalyst for a new series of paintings: 12 views of the artist's garden.

Anthony Adoring Mary, 2015. PG48

A pair of etchings, printed in light red with the lover flying from sheet to sheet. Each pair, in an edition of 25, is decorated with watercolour variations. Finally Green gets his girl.

Anthony and Mary, 2017. PG52

The same as PG48 but on one sheet of paper. Each of the edition of 25 uses hand coloured variations. This artist's proof is unique: a pencilled idea of the artist curving up towards the girl.

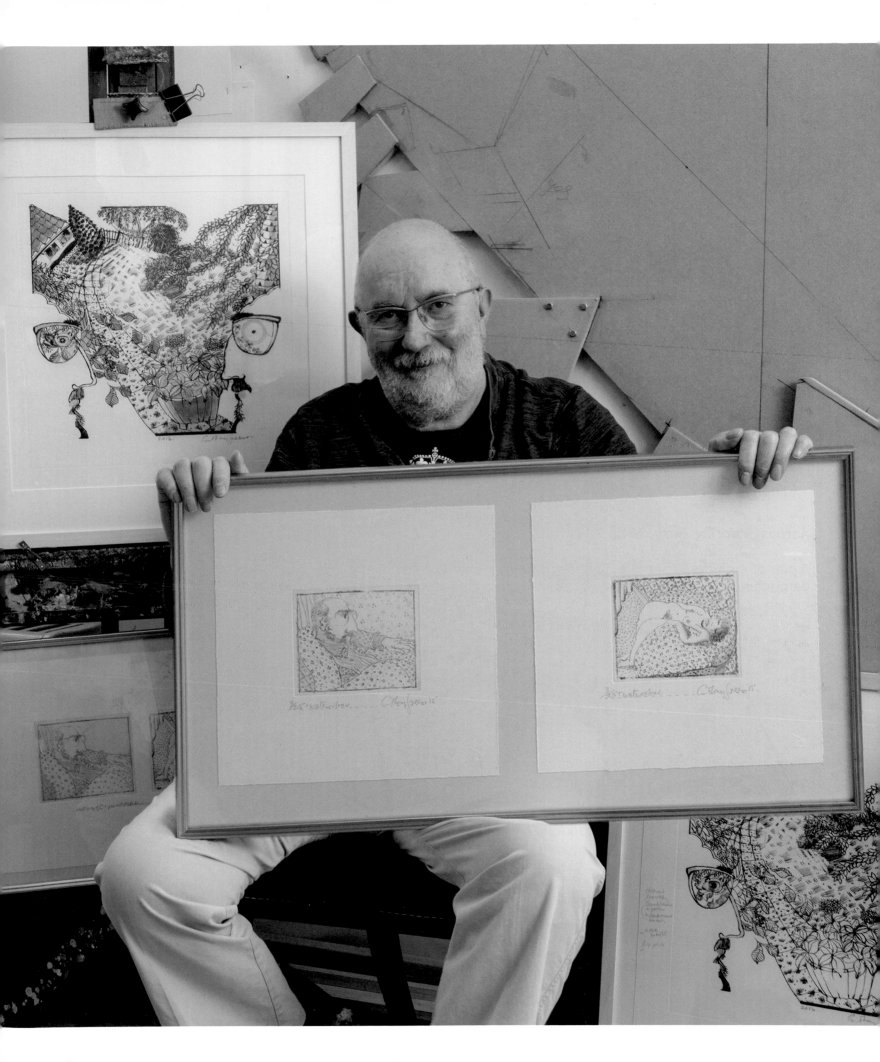

Mary in a nightie

At a Slade School of Art 'hop' in 1967 I had eyes only for Mary Cozens-Walker. On Fifth Avenue, New York, in 1979 I purchased a pale pink nightie for her. In 2017, I hope this printed picture, *A Golden Wedding*, will do.

A Golden Wedding,
2011. PG42

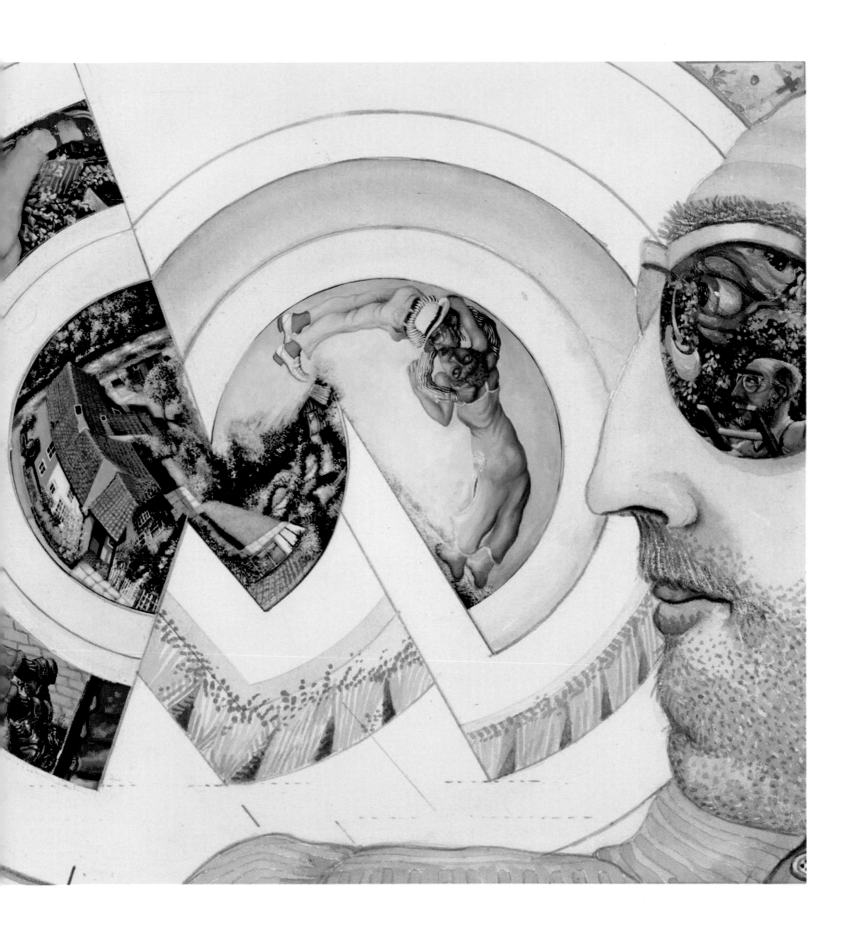

Monbretia – The Reflection, 2009. AG490

Aldeburgh I: The Scallop, 2011. AG503

Bramley, 2011. AG513

I have pictures in my mind. A headful. Edge to edge.

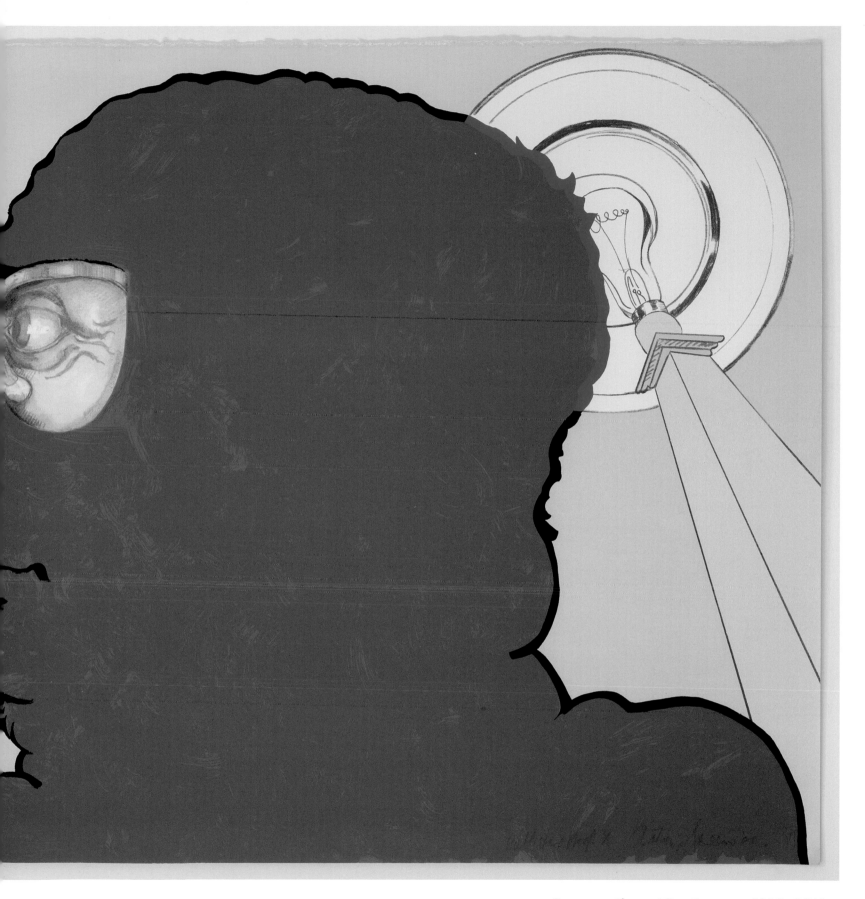

Resurrection – The Creator, 2000. PG12

When I left the Slade in 1961, I abandoned fixed viewpoints. Everyone's memories are filled with an infinite relay of images. We picture the way home, recognise our partners, perhaps watch moving pictures on TV, eat, go to bed and start off again the next day.

Selected Sources

Bailey, Martin, ed. *Anthony Green – Painting Life* (London: Royal Academy of Arts, 2017)

Beechey, James, & Stephens, Chris, eds, *Picasso and Modern British Art* (London: Tate Publishing, 2012)

Brown, Neal, *Tracey Emin* (London: Tate Publishing, 2006)

Cozens-Walker, Mary*, Objects of Obsession 1955-2011 – A Pictorial Autobiography* (London: Healeys Print Group, 2011)

Emin, Tracey, *Tracey Emin – Works 2007-2017* (New York: Rizzoli, 2017)

Freeman, Julian, *British Art: A walk round the rusty pier* (London: Southbank Publishing, 2006)

Gayford, Martin, *British Figurative Art, Part One: Painting – The Human Figure* (London: Momentum, 1997)

Gayford, Martin, *Modernists & Mavericks: Bacon, Freud, Hockney & The London Painters* (London: Thames & Hudson Ltd, 2018)

Gombrich, E H, *The Image and the Eye: Further Studies in the Psychology of Pictorial Representation* (London: Phaidon, 1982)

Green, Anthony, *a green part of the world*, Bailey, Martin, ed (London: Thames and Hudson, 1984)

Green, Anthony, *Flowers, Clouds, Corsets and a Cactus* – Paintings, Working Drawings and Pages from the Sketch Books (London: Richmond Hill Gallery, 2010)

Gresham, Kip, *10 Years* (Cambridge: The Print Studio, 2012)

Hallett, Mark, Turner, Sarah Victoria, & Feather, Jessica, T*he Great Spectacle - 250 Years of the Royal Academy Summer Exhibition* (London: Royal Academy of Arts, 2018)

Hyman, Timothy, 'Family History: Anthony Green and Contemporaneous Art', *The London Magazine* (London: Alan Ross, 1987)

Hyman, Timothy, *The World New Made: Figurative Painting in the Twentieth Century* (London: Thames & Hudson, 2016)

Lower, Lizzie, *Viva* (Brighton: Viva Brighton, 2018)

Lucie-Smith, Edward & White, Patricia, *Art in Britain 1969-70* (London: J M Dent & Sons Limited, 1970)

Marr, David, *Vision: A Computational Investigation into the Human Representation and Processing of Visual Information* (New York: W H Freeman & Co, 1982)

Martin, Simon, *Edward Burra* (Farnham, Surrey: Lund Humphries, 2011)

Mullins, Charlotte, ed, *Prints 2000* (London: Art Review, 2000)

Penrose, Antony, *The Home of The Surrealists: Lee Miller, Roland Penrose and their circle at Farley Farm House,* 2nd edition (Chiddingly, East Sussex: Penrose Film Productions Ltd, 2016)

Perry, Grayson, *Playing to the Gallery (*London: Penguin Books, 2014)

Perry, Grayson, *Making Meaning* (Vero Beach, Florida: Windsor Press, & London: Royal Academy of Arts, 2018)

Roboz, Zsuzsi, Lucie-Smith, Edward, & Wykes-Joyce, Max, *British Art Now: A Personal View* (London: Art Books International, 1993)

Rosslyn, Helen, *A Buyer's Guide to Prints* (London: Royal Academy of Arts, 2018)

Spencer, John, ed, *Stanley Spencer: Looking to Heaven* (London: Unicorn Press Ltd, 2016)

Williams, Kyffin, *Portraits,* 2nd edition (Llandysul, Ceredigion: Gomer Press, 2007)

Exhibition Catalogues

Anon, *British Painting 1952-1977,* The Royal Academy, 24 September – 20 November 1977 (London: The Royal Academy, 1977)

Anon, *Anthony Green RA: The Life and Death of Miss Dupont,* Tennant Gallery, 18 January – 30 April 2017 (London: The Royal Academy, 2017)

Bailey, Martin, & Green, Anthony, *One Day in the Life of a Picture* – Anthony Green, touring exhibition of Japan 1984-85 (Edinburgh: Scottish Arts Council, 1984)

Brown, Dr David, 'Introduction', *Aspects of British Art Today,* British Council Exhibition Tour of Japan (Osaka: The Asahi Shimbun, 1982)

Crippa, Elena, ed, *All Too Human: Bacon, Freud and a Century of Painting Life,* Tate Britain, 28 February – 27 August 2018 (London: Tate Publishing, 2018)

Davies, John, ed, *Anthony Green RA – A Love Story 1958-2013: A Retrospective Exhibition Celebrating 55 Years Of The Artist's Life And Passions*, Moreton-in-Marsh, 8 June – 6 July 2013 (Moreton-in-Marsh, Gloucestershire: johndaviesgallery, 2013)

Green RA, Anthony, ed, T*he Royal Academy Illustrated 1982: A Souvenir of the 214th Summer Exhibition* (London: The Royal Academy Illustrated, 1982)

Green RA, Anthony, *Resurrection*: *A Pictorial Sculpture for the Millennium, touring exhibition 1999-2000* (London: Napier Jones Ltd, 1999)

Green, Anthony, *Introduction, Anthony Green RA: Earthly Delights 1972-2006,* Richmond Hill Gallery, 10 November – 3 December 2006 (London: Richmond Hill Gallery, 2006)

Hyman, Timothy, *Narrative Paintings: Figurative Art of two generations selected by Timothy Hyman* at Arnolfini, Summer 1979 (Bristol: Arnolfini, 1979)

Hyman, Timothy, Gilman, Derek, Green, Anthony, *Anthony Green's Mirror* (University of East Anglia: Sainsbury Centre for Visual Arts, 1989)

Lucie-Smith, Edward, ed, *La Peinture Anglaise Aujourd'hui,* Musee d'Art Moderne de la ville de Paris (Paris: Musee d'Art Moderne de la ville de Paris, 1973)

Nickerson, Fiona, & Wootton, David, eds, *Chris Beetles Summer Show 2016* (London: Chris Beetles Ltd, 2016)

Nozomi Endo, Junich Shioda, Miki Numazawa, Masako Shimizu, Noriyoshi Takaragi, Hiroshi Sato, Yoshiharu Sasaki, & Fusako Araki, eds *Anthony Green, 1960-68*, touring exhibition of Japan 31 October 1987 - 15 May 1988, (Tokyo: The Japan Association of Art Museums/The Yomiuri Shimbun, 1987)

Packer, William, 'The First Show', *Anthony Green RA: Paintings 1958-2008.* Richmond Hill Gallery, 14 November - 6 December 2008 (London: Richmond Hill Gallery, 2008)

Robertson, Bryan, *Anthony Green paintings*, Rochdale Art Gallery, and touring exhibition, 21 January – October 1977 (publication details unknown)

Seres, Karen, & Wright, Barnaby, eds, S*outine's Portraits: Cooks, Waiters & Bellboys*, The Courtauld Gallery, 19 October 2017 – 21 January 2018 (London: The Courtauld Gallery in association with Paul Holberton Publishing, 2017)

Whitford, Dr Frank, unpublished draft of *The Marvellous Mundane* (Tokyo: Nishimura Gallery Catalogue, 1992)

Wootton, David, & Oakley, Pascale, *Anthony Green RA: Among Royal Academy Artists and Friends*, Chris Beetles Gallery, 30 May - 18 August, 2018 (London: Chris Beetles Ltd., 2018)

Online Interviews (YouTube accessed April 2018)

Anthony Green RA, *Resurrection* at the Greenbelt Festival 2012, interview by Paul Northup, Director of Greenbelt, published 24 August 2012, 12.40 minutes, https://www.youtube.com/watch?v=l9lbC8iLnQk#t=727.665941 (accessed May 2018)
The Threadneedle Prize: Anthony Green interview, interviewer unknown, published 5 November 2008, 0.48 minutes, https://www.youtube.com/watch?v=Q9B-bLdBMrI (accessed May 2018)
'An Evening with Anthony Green RA', interview by Dr Frank Whitford, Wolfson College, Cambridge, 2 May 2013, 59.03 minutes, https://www.sms.cam.ac.uk/media/1473422 (accessed May 2018)
'Private Passions: Anthony Green', interview by Michael Berkeley, BBC Radio 3, 30 November 2014, 31 minutes, https://www.bbc.co.uk/programmes/p02cv49b/p02cv5dh (accessed May 2018)
'Anthony Green RA: The Life and Death of Miss Dupont', interview by Alika Francis, Winkball, published 23 January 2017, 2.45 minutes, https://www.youtube.com/watch?v=io_Xc6k-sUM (accessed May 2018)
'Anthony Green RA in conversation with Timothy Hyman' RA, Royal Academy of Arts, [2017?], 55.35 minutes, https://soundcloud.com/search?q=anthony%20%20green%20ra (accessed May 2018)

Television Programmes

Anthony Green: Now and Then, Arena, BBC, 1979, Director: Nigel Williams
Human Brain: Seeing, BBC, 1982, Producer: Robin Brightwell
Sheridan Morley meets Anthony Green RA, BBC East, 1984
Some Reflections on the Life and Times of Anthony Green RA: A Love Story, (South Bank Show with Melvyn Bragg), ITV, 1987, Director: John Read. Repeated, with additions, as South Bank Show Originals, Sky Arts, 7 August 2018
Anthony Green RA: 57 Up, Omnibus Review, BBC2, 1997, Director: Nigel Williams
Anthony Green RA: The Works! Opus School of Textile Arts, 2003, Directors: Julia and Alex Caprara

The Buckingham Prints Catalogue

After retiring from the Council of the University of Buckingham, Anthony Green generously donated one numbered copy from nearly all of his print editions to the University which now possesses an almost complete archive.

PG1 *Kissing Couple*, 1962-63 Woodcut print, 11 x 7.5 cms. Edition of 5. Edition number 5/5

PG2 *Kiss At The Ritz*, 1988 Lithograph, 62 x 68 cms. Edition of 75. Edition number 55/75

PG3 *The Garden/Anthony And Rosie*, 1988 Lithograph, 61 x 63.5 cms. Edition of 75. Edition number 11/75

PG4 *Mary Cozens-Walker's Box And Anthony Green's Tent,* 1985 Lithograph, 87 x 117 cms. Edition of 75. Artist's proof V/X

PG5 *Flowers On Margaret's Trestle Table*, 1988 Black and white lithograph, 30 x 20.5 cms. Edition of 20. Edition number 18/20

PG6 *Lovely*, 1995 Soft ground etching, 18 x 13.5 cms. Edition of 30. Edition number 26/30

PG7 *Splendour,* 1995 Soft ground etching, 19 x 16 cms. Early proof

PG8 *Vase Of Flowers*, 1995 then coloured in 2009 Soft ground etching, 19 x 15 cms. Edition of 90. Edition number 51/90

PG9 *Vase Of Flowers*, 1995 Soft ground etching, 19 x 15 cms. Edition of 90. Edition number 52/90

PG10 *Bob Going To Heaven Quickly*, 1999 Screenprint, 77 x 56 cms. Edition of 100, Artist's proof IX/X

PG11 *The Young Artist Unknowingly Going To Heaven*, 2000 Screenprint, 76 x 112 cms. Edition of 75. Edition number 73/75

PG12 *Resurrection: The Creator*, 2000 Screenprint, 75 x 110 cms. Edition of 70. Artist's proof V/VII

PG13 *The Clock – Marie Madeleine (Version I)*, 2000 Screenprint, 76 x 89 cms. Edition of 70. Artist's proof I/V

PG14 *Railway To Heaven*, 2001 Screenprint, 111 x 74 cms. Edition of 75. Edition number unknown

PG15 *Yvonne Lissac: Une Vie*, 2003 Inkjet print, 76 x 151 cms. Edition - unique half size print. Trial print

PG16 *The Clock – Marie Madeleine (Version II)*, 2003 Inkjet print, 75 x 104.5 cms. Edition of 50. Edition number 6/50

PG17 *An Enigma – The Artist's Father (1899-1961)*, 2003 Inkjet print, 111 x 96 cms. Edition of 50. Edition number 10/50

PG18 *Famille Lissac*, 2003 Inkjet print, 111 x 76 cms.
Edition of 50. Edition number 15/50

PG19 *He Never Took His Eyes Off Us*, 2003 Inkjet print, 111 x 75 cms.
Edition of 50. Edition number 4/50

PG20 *Making Heaven Happen*, 2003 Inkjet print, 111 x 75 cms.
Edition of 50. Edition number 4/50

PG21 *Tent Of Eternal Love*, 2003 Inkjet print, 53 x 76 cms.
Edition - unique half size print. Trial proof

PG22 *A Ruby Wedding Anniversary*, (A joint work by Mary Cozens-Walker
and Anthony Green) 2003 Lithograph, 46 x 66 cms.
Edition of 150 published by Curwen Press. No edition number

PG23 *The Green Garden*, (smaller version) 2003 Inkjet print, 40 x 60 cms.
Edition of 20. Artist's proof

PG24 *Golden Garden*, 2003 Inkjet print, 60 x 47 cms.
Edition of 100. Edition number 31/100

PG25 *The Divine Dream*, 2003 Inkjet print, 58.5 x 48 cms.
Edition of 100. Edition number 52/100

PG26 *La Côte d'Azur*, 2003 Inkjet print, 47 x 62 cms.
Edition of 50. Artist's proof II/XV

PG27 *Tootsie*, 2004 Inkjet print, 61 x 62 cms.
Edition of 50. Trial proof

PG28 *The Garden Sheds*, 2004 Inkjet print, 59 x 59 cms.
Edition of 50. Edition number 35/50

PG29 *Pâtisserie*, 2005 Inkjet print, 70 x 50 cms.
Edition of 50. Edition number 21/50

PG30 *Marie Madeleine (1910-2004)*, 2005-2009 Etching and hand watercolour/
waterstamp, 168 x 122 cms. Edition of 10. Unique proof

PG31 *The Flower Painter*, 2006 Inkjet print, 71 x 59 cms.
Edition of 70. Edition number 2/70

PG32 *Homard Newburg*, 2006 Inkjet print, 64 x 102 cms.
Edition of 50. Edition number 19/50

PG33 *Nasturtiums*, 2007 Inkjet print, 63 x 63 cms.
Trial proof 1. Large format not editioned

PG34 *Vélo*, 2007 Inkjet print, 60 x 72 cms.
Edition of 50. Edition number 8/50

PG35 *Blue Pyjamas*, 2007 Inkjet print, 50 x 60.5 cms.
Edition of 50. Edition number 25/50

PG36 *New Rose Bushes II*, 2008 Inkjet print, 62 x 70 cms.
Edition of 25. Edition number 6/25

PG37 *RA Bathtime II*, 2008 Inkjet print, 52 x 60.5 cms.
 Edition of 50. Final proof

PG38 *Autumn Love I - Pink Lounge*, 2009 Etching and inkjet print, 86 x 70 cms.
 Edition of 20. Edition number 4/20

PG39 *Autumn Love II - The Swing*, 2009 Screenprint and inkjet print, 51 x 50 cms.
 Edition of 35. Artist's proof V/V

PG40 *Autumn Love III - Red Hot*, 2009 Etching and inkjet print, 51 x 46 cms.
 Edition of 50. Edition number 7/50

PG41 *Mr And Mrs Green And Their Fox Terriers*, 2009 Inkjet print, 39 x 54 cms.
 Edition of 50. Edition number 18/50

PG42 *A Golden Wedding*, 2011 Inkjet print, 30.5 x 38 cms.
 Edition of 100. Edition number 56/100

PG43 *Tootsie! Don't Sit On The Quilt*, 2012 Inkjet print, 20 x 20 cms (diamond
 shaped). Edition of 100. Edition number 38/100

PG44 *Stiffkey – The Old Hall/Painting The Picture*, 2012, Inkjet print. 65 x 90 cms.
 Edition of 10. Artist's proof

PG45 *The Blue Bedroom*, 2013 Inkjet print, 51 x 51 cms.
 Artist's proof 1/1 final version

PG46 *L'Equipe I*, 2012 Screenprint and hand colour, 60 x 60 cms.
 Edition of 100. Edition number 11/100

PG47 *Girl In His Pocket*, 2012 Screenprint and hand colour, 38 x 27 cms.
 Edition of 25 artist's proofs. Edition number 7/25 plus watercolour

PG48 *Anthony Adoring Mary*, 2015 Two soft ground etchings (printed in light
 red) with hand watercolour and pencil, Framed size 43 x 82 cms.
 Edition of 25 artist's proofs. Edition number 3/25

PG49 *The Garden At Little Eversden: Monkey Puzzle And A Tub Of Hydrangeas I*,
 2016 Etching cut-out and watercolour, 41 x 41 cms. A working proof

PG50 *The Garden At Little Eversden: Monkey Puzzle And A Tub Of Hydrangeas II*,
 2016 Etching and watercolour and colour instructions in pencil, 41 x 41 cms.
 A working proof

PG51 *Le Peintre A Contre Jour Aux Immortelles*, 2016 Black and white etching,
 22 x 19 cms. Artist's proof

PG52 *Anthony And Mary*, 2017 Two soft ground etchings printed in light red on
 one sheet of paper, 32 x 51 cms. Artist's proof and pencil sketch

PG53 *L'Equipe II*, 2017 Screenprint and inkjet print, 60 x 60 cms.
 Edition of 25. Artist's proof

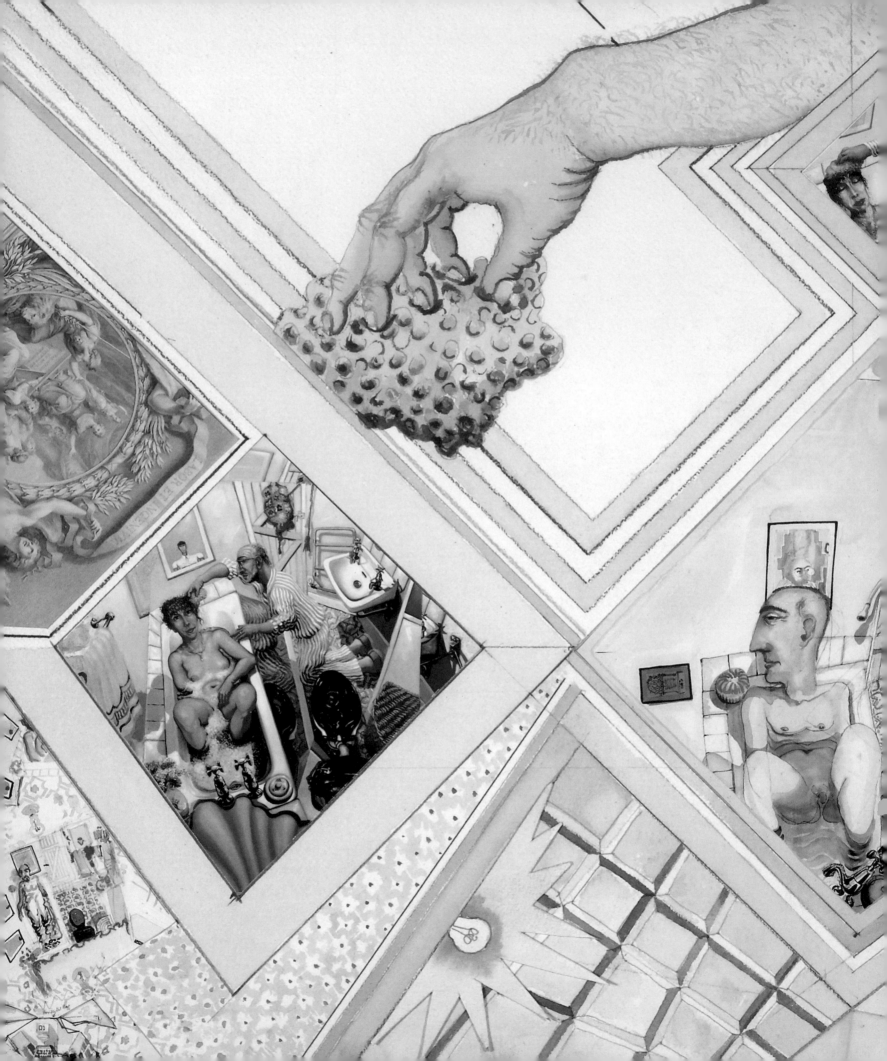